IMAGES
of America

VENICE
IN THE 1920s

A Tropical Playground~*A Fisherman's Paradise!*

VENICE—where miles of shimmering white beach reflect the rays of the morning sun—where cool Gulf breezes bring nights of refreshing rest—where flaming Hibiscus and Poinsettia lend colorful contrast to the eternal green of tropical foliage.

Out in the open Gulf, the angler pits his skill against Kingfish, Sailfish or the mighty Tarpon. In pass and bay the "fightin' snook" (Roballo) and speckled trout rise to their favorite lures.

Surf bathing—surf riding—motor and sailboating—golf—tennis—every form of health-giving outdoor recreation fills the day at Venice with pleasure.

Famous chefs tempt diners whose appetite needs no whetting—social contact with one's own kind.

No wonder that they who come to Venice to play remain to live and work and prosper, when one considers that this new empire is a year-round resort and industrial city, backed by adequate financial resources and its 25,000-acre farming community.

Twelve months of growing weather—well-drained, productive soil—ready-to-farm tracts—a quick market—ideal living conditions—healthful climate—and a beautiful modern city. Venice offers unlimited agricultural, commercial and recreational opportunities.

IMAGES
of America

VENICE
IN THE 1920S

Gregg M. Turner

ARCADIA

Published by Arcadia Publishing,
an imprint of Tempus Publishing, Inc.
2 Cumberland Street
Charleston, SC 29401

Printed in Great Britain.

Library of Congress Catalog Card Number: 00-101917

For all general information contact Arcadia Publishing at:
Telephone 843-853-2070
Fax 843-853-0044
E-Mail sales@arcadiapublishing.com

For customer service and orders:
Toll-Free 1-888-313-2665

Visit us on the internet at http://www.arcadiaimages.com

For Eddie & Louise and Joe & Lola, who showed us kids the wonders of Florida.

CONTENTS

ACKNOWLEDGMENTS

Without the help, cooperation, and support of Dorothy Korwek and the Venice Archives and Area Historical Collection this book would not have been possible.

Other individuals who deserve recognition include Joan Morris, Florida State Photo Archive; Cynthia Wise, Florida State Library; Lorna Knight, Laura Linke, and C.J. Lance-Duboscq, Kroch Library, Cornell University; Mark Smith, Historical Resources, Sarasota County Government; Clifford Lund; Pamela Thornlow; and M.J. "Mo" Morrow and John Bentley Jr., Brotherhood of Locomotive Engineers in Cleveland, Ohio.

To all I extend a sincere word of thanks!

—G.T.

All images in this book, unless otherwise credited, were furnished by the following:

Venice Archives and Area Historical Collection
351 South Nassau Street
Venice, FL 34285
(941) 486–2487

INTRODUCTION

Florida is a great laboratory of town and city planning and building. Almost everything that is good and everything that is bad is to be seen in the flesh.

—City Planner John Nolen, 1926

Over the decades Venice, Florida, has become a Mecca for tourists, transplants, and retirees. Located on the lower Gulf Coast below Sarasota, the city boasts a balmy climate, unlimited boating and fishing, and a famous ocean beach; further, many of its homes and buildings have a unique Spanish flavor and front on a friendly network of streets and parks. The "City By the Gulf" actually came of age during the spectacular Florida Land Boom of the 1920s. In the pages ahead we explore how this remarkable story unfolded, but our journey first begins with something about the Boom itself.

Boom fever, which was fueled by money, newcomers, construction, promotions, and real estate, affected virtually every region of the Sunshine State. In fact, enough Florida land was subdivided during the era as to completely re-house the then-existing population of the United States. By the mid-1920s, no less than 24 new communities had surfaced along Florida's extensive coastline. One of them was Venice.

The Boom was largely financed by postwar prosperity. Farmers had grown rich meeting wartime demands, factory workers had accumulated savings, and many manufacturers and industrialists had made fortunes during the First World War. Bank deposits stood at record levels, which put bankers and financiers in an expansive mood. Once the armistice was signed, many Americans started to turn their thoughts toward travel and vacations, and there was no more of an inviting destination than sunny Florida—land of emerald waters, tropical flowers, and royal palms. Waves of people soon descended upon the Sunshine State. Many arrived in the family car (as Tin Can Tourists) but shiny limousines also came down Florida roadways like the Dixie Highway. Other newcomers traveled by airliner, boat, or private yacht. Countless, though, arrived by train—in coach, Pullman, and private rail cars. In fact the demand was so great during the Boom that new trains had to be introduced and extra sections added to existing runs.

To the joy of Floridians, these vacationers and newcomers started to pour serious money into the state's economy. Hotel, apartment, and lodge owners immediately benefited as did store proprietors and restaurateurs. Many snowbirds liked what they saw and decided to purchase a place in the sun, or at least buy land for a future home. This paved the way for numerous construction projects around the state. New subdivisions appeared and service industries flourished. Then, many folks started to speculate in real estate, buying something one year and

selling it the next at a handsome profit. Others tried "turning" their investment the same season, the following month, or even the same day. Real estate success stories became commonplace and were circulated "up North" to friends and neighbors, who in turn came down to learn more about the Florida miracle. And in this way the frenzy began. Between 1923 and 1925 an estimated 300,000 people permanently settled into the Sunshine State. Over a dozen new counties were created during the Roaring Twenties, and it was estimated that in 1925 alone some 2.5 million people visited the state. Everyone, it seemed, wanted a piece of the new American *El Dorado*.

It was between October and April of each year that Florida's railroad companies made their real money. But in the spring of 1925, the normal lull did not occur. People from every section of the United States began to pour into Florida as never before, further increasing the demand for new accommodations, homes, and every kind of public utility. This prompted Florida's merchants and contractors to order inventory far in excess of actual requirements. Train loads of materials and supplies were often shipped to the "Empire in the Sun" with no specific destination, changing hands many times while en route, and frequently reaching a locale where no service tracks or warehouse facilities existed. The result? Thousands of freight cars became stranded, occupying every available track, tying up rail yards, and choking the movement of traffic. To relieve the congestion, the "Big Three" railroads (Atlantic Coast Line, Seaboard Air Line, and Florida East Coast) called for a statewide embargo that took effect on October 29, 1925. Traffic was halted except for shipments of foodstuffs, fuel, and a few essential commodities. When the embargo was called, nearly 4,000 freight cars were jammed at the Jacksonville yards (the nerve center of the state), and another 10,000 were ordered to be held at various points between Washington, D.C., Cincinnati, St. Louis, and New Orleans. Traffic experts from around the country were rushed in to untangle the mess, but it was not until May of the following year that order was restored. By then, though, the Boom had ended.

More than one developer made their reputation during the Boom era. George Merrick conceived the model suburb of Coral Gables, while Carl Fisher forever put Miami Beach on the map. After designing posh estates at Palm Beach, a portly Addison Mizner drew plans for the architectural playground called Boca Raton. The renowned aviator Glen Curtis developed Hialeah and Opa Locka, the latter replete with Arabian-like buildings. Hollywood-By-The-Sea was the dream of Joseph Young, who engaged General George Washington Goethals (of Panama Canal fame) to create Venetian-like harbors and canals. D.P. Davis—a titan developer if ever there was one—created Tampa's Davis Island communities, which boasted the world's largest lighted fountain, the second-largest coliseum in the nation, and a clubhouse with a sliding roof for starlight dancing. Then there was circus magnate and art connoisseur John Ringling, who gambled a fortune on Ringling Isles in Sarasota. Spectacular resort hotels also arose during the Boom, as did municipal buildings, churches, theaters, schools, homes, and even railroad stations. Most were conceived in the popular Mediterranean Revival style.

Unfortunately, the Boom also had a seamy side. Crooked developers dotted the landscape, as did high-pressure salesmen called "Binder Boys." Fraud and trickery were committed, many investors were bilked, and more than one project ran out of cash or was never built. Stories about these indiscretions appeared in the national press, which prompted Governor John Martin to hold a press conference in New York City. He titled it "The Truth about Florida." The talks helped, but they did not completely erase the public's fears about the Sunshine State.

At the height of the Boom, when many believed that the bubble had finally burst, there came the news that a new resort city would be built on the Gulf Coast below Sarasota. At the time, the setting was nothing more than a tropical wilderness with a magnificent mainland beach. A city had been promulgated at the site twice before, yet was never built. What the vision needed was a big, daring organization to develop it, one that had deep pockets and the foresight to engage creative minds to build it. In the fall of 1925, the dream crystallized. All eyes turned to Venice and the organization that was destined to develop it—the Brotherhood of Locomotive Engineers, the oldest, largest, and richest union in the country.

One
PLAYERS AND PLANS

The first government surveys of Venice were conducted in the late 1840s. Army Captain John Casey of Tampa aided in the work, and the inlet at Venice was named for him. Venice was then part of Manatee County, where cattle outnumbered people. After the Civil War, settlers and homesteaders began to trickle in. The area was originally called "Horse & Chaise," for a clump of timber at the shoreline reminded passing "fisherfolk" of a horse and buggy. When a post office was established in 1888, the name "Venice" was adopted.

On the eve of the 20th century, a mere 20 households existed in Venice. Most folks fished, hunted, grew vegetables, or tended citrus. A turpentine and lumber industry emerged thanks to the huge stands of longleaf and slash pine. Joseph Lord, a Maine native, was among those who leased land for naval stores. The Lord syndicate acquired large, undeveloped tracts in the region and eventually sold parcels from a Chicago office.

While perusing a newspaper on a cold winter day in 1910, a wealthy Chicago widow by the name of Bertha Honore Palmer read one of Lord's ads. She found it inviting, and soon a Palmer entourage left by private rail car for Sarasota. Lord not only sold the family orange groves and pine lands, plus bay and oceanfront parcels, but he became an officer of the Sarasota-Venice Company, which Bertha formed to develop and market the properties. Within seven years, the Palmer family would own over 1/4 of modern-day Sarasota County, from Oneco south to Venice. It was also Bertha Palmer who convinced officials of the Seaboard Air Line Railway to extend their line south of Sarasota to Venice proper.

In February 1915, the Sarasota-Venice Company filed a plat calling for a Venice town site near the Seaboard track. Lots were advertised at $875 without improvements, but what the Palmer family really wanted was a resort city, one that capitalized on the glorious ocean beach. Later that year, Bertha hired planner Charles Wellford Leavitt of New York City to produce a town plan, and in the fall, the Leavitt design, replete with a resort hotel, civic center, golf course, yacht club, school, church, stores, canals, and parks, was unveiled. Unfortunately, the cost of creating such a city shocked the Palmers, and the plan was rejected. Instead, Bertha built a "close to nature" community over at Eagle Point between Curry and Hatchett Creeks.

Operations of the Sarasota-Venice Company were deeply affected by the First World War. Farm labor became scarce, costs escalated, and prospects for land purchases dwindled. Quickly, an aggressive marketing campaign was instituted. In Venice, bayfront parcels were advertised for a mere $56 an acre, Gulf-front for $65. In March 1917, a splendid 112-acre parcel situated on Dona Bay was sold to a renowned orthopedic surgeon, and a new chapter in Venice history began.

Dr. Fred Albee grew up in Maine and knew the harsh realities of farm life and of the scarcity of money. As a child, he had dreamed of becoming a doctor and of creating a city where "all rooms would be heated." Albee graduated from Harvard Medical School, practiced in Connecticut and New York City, and taught at Cornell and Columbia. Reconstructive bone surgery became his forte, and in time, inventions like the Albee Bone Mill, the Albee Orthopedic Fracture Table, and the Albee Motor Saw appeared. At the behest of friends, Albee and his wife visited the Nokomis area during the war and stayed at the "Maine Colony" on Phillipi Creek. Overnight he became sold on Florida, and in March 1917, he purchased the village of Nokomis and Bay Point from the Palmer land company for less than $12,000. On subsequent trips, his holdings were enlarged, and eventually, Albee built the Pollyanna Inn resort and a beautiful winter estate.

But it was during the Florida Land Boom that Dr. Albee acquired a crown jewel. Among the tracts the Palmers had for sale was a 1,468-acre parcel where most of the City of Venice would one day sit. Albee bought the land in August 1924 for $185,000 (about $130 an acre). The surgeon, now the owner of almost 30 miles of Gulf-front and bayfront land, began asking himself an important question: How should Venice and Nokomis be properly developed? For advice on that matter he turned to another Harvard mind, the eminent city planner John Nolen.

In August 1925, Albee wrote to Nolen at his Cambridge, Massachusetts office and asked how he should proceed. Nolen offered to provide Albee with several services, including sketches of his Venice-Nokomis holdings as well as a regional plan of development. Albee subsequently engaged Nolen, and soon Hale Walker (a Nolen staffer) appeared on the scene to prepare an investigative report. In it, Walker noted that Venice had "high pine land . . . fine jungle land near the shell banks . . . and an extremely fine beach." Walker envisioned Venice as an important shipping point for citrus, fish, and perhaps a sponge industry. Shops and homes would dot the Venice town site, and there would be a golf course, boat club, and "punts for shallow water gondolas at hotels." Trails, tea houses, dancing places, and picnic groves were also mentioned in the Walker study.

Whereas Nolen prepared sketches for the Venice-Nokomis project, the surgeon decided to subdivide and sell Bay Point (Nokomis) first, because quick cash could be raised from lot sales. Later, Albee turned his attentions to "Venice Beach," the name he had given to the Venice city. Nolen released a new Venice Beach plan in January 1925. In the revised plan, the Tamiami Trail was straightened and the Seaboard track was relocated farther east to accommodate the new city.

But Venice Beach was never built because Fred Albee felt that the timing was wrong, the real estate markets weak. Further, his Bay Point project in Nokomis had satisfied much of his childhood dream of creating a city. Louella Albee, in turn, reminded her husband of his growing surgical practice and that building Venice Beach would be an enormous strain. In fact, she advised him to sell the "blue-printed" city. And he did! After receiving a dozen offers, Albee wrote to John Nolen and reported that Venice Beach had been sold, but not to a typical real estate developer. The torch had been passed to a great American union—the Brotherhood of Locomotive Engineers.

Bertha Honore Palmer (1849–1918) inherited a real estate fortune from her merchant husband, Potter Palmer. The Chicago social queen also invested in real estate and once owned the land on which the future city of Venice would one day be built. She had a winter estate at nearby Osprey.

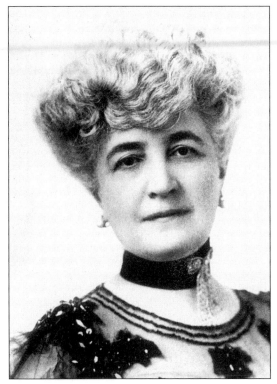

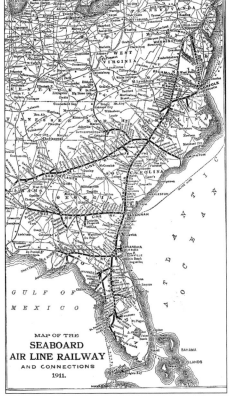

MAP OF THE
**SEABOARD
AIR LINE RAILWAY**
AND CONNECTIONS
1911.

In 1910, Bertha Palmer convinced Seaboard railroad officials to extend their line from Fruitville (Sarasota) to the tropical wilderness of Venice. The 16-mile extension, visible in this map, opened with little fanfare in the fall of 1911. Venice remained the southernmost point of the railroad system until the Florida Land Boom years.

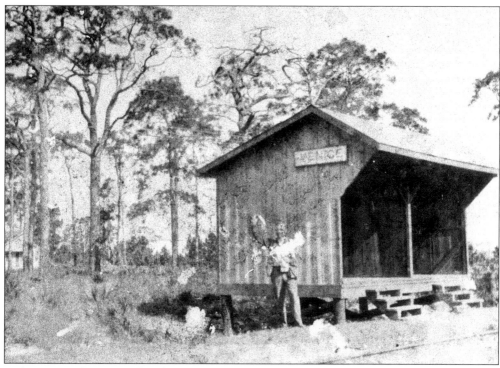

Perhaps two dozen families lived in Venice when the first Seaboard train arrived, and eventually a shed-like station appeared. A double set of steps and a wooden partition separated white and "colored" patrons.

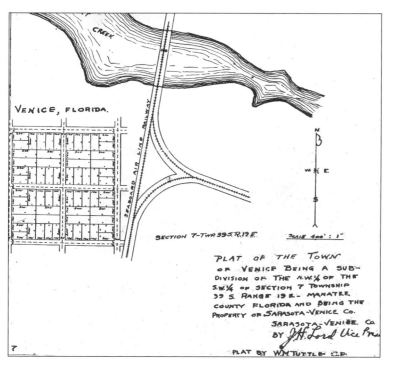

Palmer's Sarasota-Venice Company filed a Venice plat in February 1915. The gridiron consisted of four blocks and six streets, the easternmost of which became Nokomis Avenue. The Seaboard railroad terminated at Venice, and the wye track for turning locomotives is visible.

Charles Wellford Leavitt (1871–1928) conceived a resort plan for Venice, after the plat seen in the previous image was filed. The cost of building it, however, shocked the Palmer family, and the plan was rejected. Leavitt, a distinguished landscape architect, went on to design racetracks, estates, and parks in the greater New York area. (Courtesy of Pamela Thornlow and the Leavitt family.)

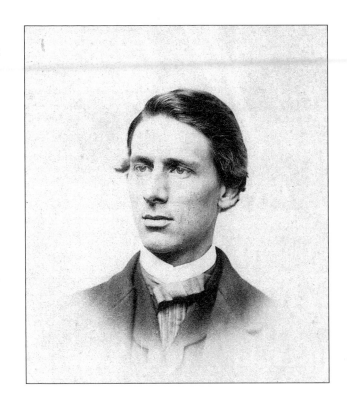

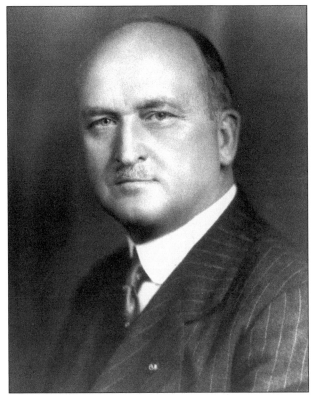

Fred Houdlette Albee (1876–1945) was born in Alna, Maine, and was one of seven children. He lectured throughout the world on bone reconstructive surgery, authored books and articles, and held several honorary degrees. Albee loved Florida and acquired most of today's Venice from the Palmer family's land corporation.

FRED H. ALBEE, M.D.
40 EAST 41ˢᵗ STREET
NEW YORK CITY
TEL. 6950 MURRAY HILL

Aug. 5th, 1924.

Mr. John Nolen,
Harvard Square,
Cambridge, Mass.

My dear Mr. Nolen:

In your busy life I hope you remember your visit to Nokomis and the view of the surrounding bays that I gave you from the top of my house.

I am a little uncertain as to what action to take toward the development of Venice-Nokomis. You will note by the combination of the names that I have acquired Venice in addition to my Nokomis holdings and I am discussing with myself what I shall do as the first step.

I think you have a very good idea of the geography of this spot. It is really a modern Venice. There are so many bays, riverlets, etc. It ought to make a most attractive town and what do you think should be done in the beginning. I do not know just your methods and would like to hear from you.

Sincerely,

Fred H. Albee

FHA:m

In 1924, after acquiring large parcels of real estate in the Venice-Nokomis area, Dr. Fred Albee wrote to city planner John Nolen for advice on how to develop his holdings. Earlier that summer, Nolen had visited the distinguished surgeon. (Courtesy of Division of Rare and Manuscript Collections, Cornell University Library.)

John Nolen (1869–1937) was an international giant in city and regional planning. He wrote books and helped establish planning degrees at Harvard and the Massachusetts Institute of Technology. The Nolen firm designed over 400 projects in America, from playgrounds to cities. One of his clients was Dr. Fred Albee. (Courtesy of Division of Rare and Manuscript Collections, Cornell University Library.)

Hale Walker, a Nolen staffer, visited Venice and prepared an investigative report of the region. This sketch (note spelling errors) was appended to his document that Walker envisioned at Venice canals and a resort hotel with gondoliers. "House Boats for pleasure purposes such as make the Thames famous should also be introduced." (Courtesy of Division of Rare and Manuscript Collections, Cornell University Library.)

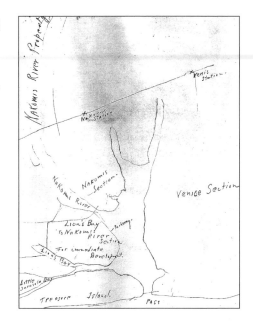

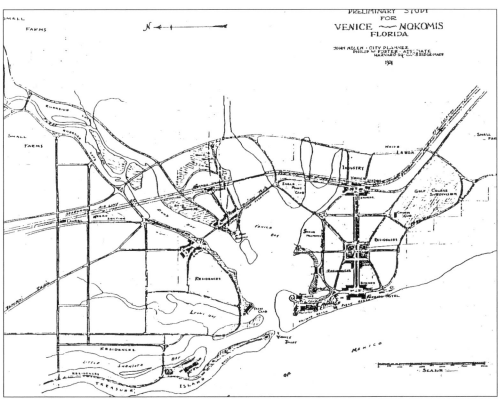

John Nolen's preliminary study of the Venice-Nokomis area appeared in 1924. Venice Beach is in the right foreground. Hispanola Boulevard (today's Venice Avenue) ran from the Seaboard station to a Gulf-side pavilion and hotel. Diagonal streets radiated from a four-block civic center. Though the plan was later revised, Venice Beach was never built.

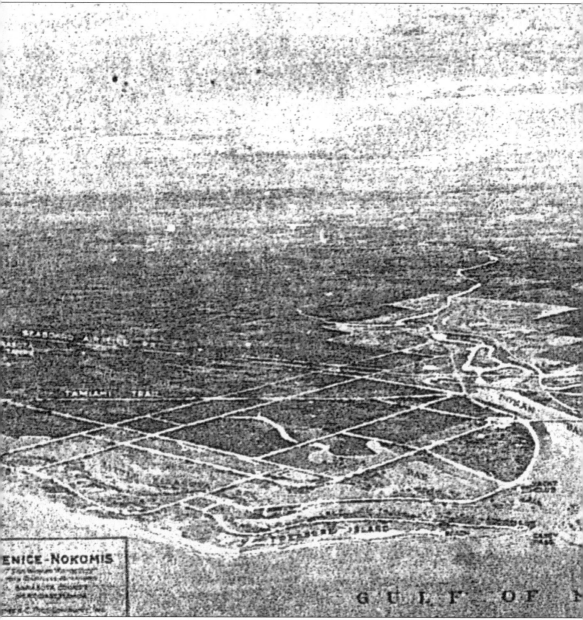

A bird's-eye view of Venice-Nokomis appeared in advertisements and brochures. Nokomis-Bay Point is on the left; Venice Beach is on the right. Albee developed the former but sold the latter to the Brotherhood of Locomotive Engineers in the summer of 1925.

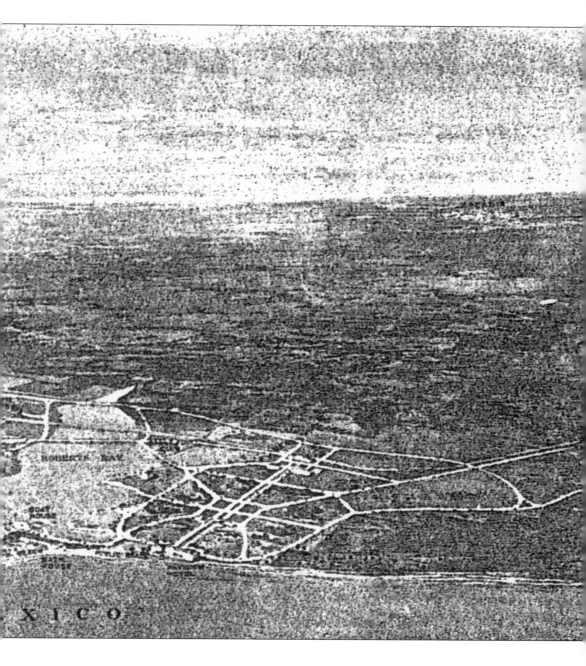

FRED H. ALBEE, M.D.
40 EAST 41ST STREET
NEW YORK CITY
TEL. 6950 MURRAY HILL

July 29, 1925.

Mr. John Nolen,
Harvard Square,
Cambridge, Mass.

My dear Mr. Nolen:

I am very happy to inform you that I have sold the Venice tract to the American Brotherhood of Locomotive Engineers, one of the largest financing firms in the country. They usually operate under the name of the Brotherhood Investment Company.

I have recommended you very highly to complete their plans as they have bought, in addition to my Venice tract, some twenty five thousand acres. I have recommended to them that they put in a canal according to Government survey, which would complete the inland water ways between Tampa and Miami. This canal would run from the Bay of Venice to the Miakka River. It would serve not only as a medium of navigation, and the missing link to inland water ways on the West Coast of Florida, but also the main drainage canal to that great area of land.

I had Mr. Webb, the Vice President of the Company, on the telephone this morning and he is contemplating getting in touch with you immediately.

Please accept my thanks for sending me the glass covered map of Bay Point.

With reference to Mr. Geo.A.Randall, I do not know anything about him. I have made some inquiries, but am unable to get any trustworthy line upon him. I also received a letter from him with reference to your work and was very glad to write him strongly recommending your work.

I was much interested in the Clewiston proposition, and propose to have Rice and his men make a thorough investigation as to just how they put it over, as it seems to be quite remarkable. There will be a considerable amount of building at Venice-Nokomis this year and things look most favorable.

Sincerely,

Fred H. Albee m.

P.S. I am very anxious to see you and talk over the future plans of the Venice Proposition with you before you see the Brotherhood people as I may be of service to you in giving you facts.

John Nolen was among the first to learn that Venice Beach had been sold. Dr. Fred Albee recommended to the Brotherhood that Nolen be allowed to carry out his great plans, and the union agreed. Nolen not only designed Venice, but he rendered plans for Clewiston, St. Petersburg, West Palm Beach, Fort Myers, and Jacksonville. He regarded Venice though as his greatest opportunity. (Courtesy of Division of Rare and Manuscript Collections, Cornell University Library.)

Two

BUILDING A CITY

In April 1863, as the Civil War gripped America, 12 men clasped their hands under an elm tree in Marshall, Michigan, and formed the Brotherhood of Locomotive Engineers. The new union was founded to "elevate their social, moral and intellectual standing, guard their financial interests, and promote their general welfare." In time, a professional journal appeared and an insurance association was formed. The organization was conservatively run, and during its first 63 years of existence, only three chief executives were elected. Among the membership roster was the American folklore hero, John Luther "Casey" Jones.

Warren Stone became the Brotherhood's Grand Chief Engineer in 1903. Eight years later, he opened an impressive headquarters building in Cleveland, Ohio. By the end of the First World War, pension and insurance funds had accumulated high balances, enough so that Stone felt the union could operate in the world of high finance. Thus began the Brotherhood's era of "labor capitalism." In rapid succession, Stone formed a chain of (coast-to-coast) cooperative banks as well as investment firms, a coal mining company, a real estate business, and a mail order enterprise. A controlling interest in New York's Empire Trust Company was also obtained, and both jointly acquired the Equitable Building in 1923, then the world's largest office complex. Though favorable publicity was accorded the union's activities, many of its endeavors met with financial disappointment.

Stone died in 1925 and was succeeded by Grand Trunk railroader William Prenter, Stone's right-hand man. Around this time, as a result of an audit, it was discovered that $1 million of "doubtful paper" existed at the Brotherhood's cooperative bank in New York. When added to other investments that had soured, the union actually faced a loss of some $4 million. To correct the problems, it was suggested that some kind of lucrative venture (a "flyer") be undertaken to recoup the losses before they became known to the membership—some 91,000 strong. And no better place to try was in Florida, where Boom stories of easy money and fast fortunes were rampant.

George T. Webb was primarily responsible for the Brotherhood's venture in the Sunshine State. Webb was the vice president of the union's investment company and an officer of Empire

Trust. During the summer of 1925, he had both coasts of Florida surveyed for a suitable opportunity, and an interesting one surfaced at Venice. There, several tracts of land were available that could be assembled into one large plat, then subdivided and resold. That Venice had railroad transportation and a 9-mile-long mainland beach heightened Webb's interest. Quickly, Albert Cummer (a Sarasota investor and developer) was hired by the Brotherhood to obtain options on the parcels. Cummer, in turn, contacted Albert Blackburn, a former ranch foreman for Bertha Palmer, and the business of assembling the plat began in earnest.

At first it was the Brotherhood's scheme to purchase the land, briefly hold it, then resell it at a sufficient profit so the aforementioned $4 million loss could be erased. But Webb, the indefatigable salesman, cajoled Brotherhood officers into believing that "developing" Venice could be infinitely more lucrative. What Webb actually envisioned was a "ready-to-wear" resort city with homes, shops, hotels, casinos, a golf course, farms, industry, and a waterway from Roberts Bay to the Myakka River—in short, a self-sustaining economic unit. Eventually, Webb overcame the criticisms and objections of fellow officers and got the investment subsidiary of the union to purchase 30,511 acres of Venice land for $4,043,092. Top-of-the-market prices were paid. The largest parcel (25,386 acres) was acquired from E.H. Price for $1,890,814 ($75 an acre) and extended the Brotherhood's holdings east of the future city to the Myakka River. Dr. Fred Albee's "Venice Beach" parcel (1,468 acres) cost $1,012,877 (about $690 an acre). Albee had owned the land for just nine weeks and had paid about $126 an acre. Eighteen other transactions were needed to complete the assemblage. To relieve Edith Just of her 7-acre parcel in Venice, the union paid $22,160 an acre. Other sellers included the old Higel and Knight families and the trustees of the Palmer family's land corporation. But Webb soon discovered that the Brotherhood's Investment Company could not take title to the land, and so BLE Realty was formed in September 1925. What the resort city would finally cost was never fully projected by Webb, nor were exact funding details. Nevertheless, people like Dr. Fred Albee had great confidence in the Brotherhood's reputation and vast financial resources. Frequently the union remarked that it would spend some $40 million on developing Venice—a million every month.

Brotherhood officials inspected their Venice tract (3 miles wide, 7 miles long) in August 1925. News of the purchase broke the following month in the *Jacksonville Times Union*, but the article did not say what the union really intended on doing with the land, though mention was made of a canal and some homes for union members. Dr. Fred Albee had recommended that planner John Nolen be retained by the Brotherhood, and Webb agreed. In the years ahead, the Cambridge, Massachusetts office of Nolen issued some 140 drawings and plans of Venice. Nolen himself would forever revere the Venice commission and called it his greatest opportunity. Albee served as a consultant to Webb and carried on with his own building plans at Nokomis and Bay Point. Southern Construction Engineers of Sarasota was hired to survey the huge Venice plat, drain the swamplands, and locate a canal to the Myakka River. The work, though, eventually overwhelmed the small firm, and they were succeeded by Black, McKenney & Stewart of Washington, D.C., who ultimately put 120 engineers on the job. Webb then gave the Venice contract to George A. Fuller Construction of Chicago, a company that had previously built a Brotherhood building in Cleveland. Walker & Gillette, a well-known architectural house in New York City, became supervising architects. Later, an up-and-coming landscape architect by the name of Prentiss French was engaged to beautify the Nolen vision. With key players now in place, it was time to build a new city.

The Brotherhood officers seen here were in power when the Venice project began. Prenter had trained on national union affairs under President Warren Stone. Later, Prenter would be removed from office when Venice and other forays went awry. Alvanley Johnston (lower left) replaced him.

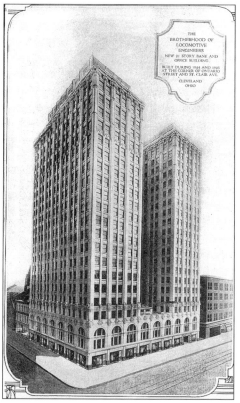

The Brotherhood's 21-story bank and office building was erected in Cleveland, Ohio, in 1924–1925. Fuller Construction of Chicago built it, and later, the company got the contract for Venice. For decades, the Brotherhood was the most powerful and richest union in the world.

George T. Webb was the BLE executive behind the Venice venture, but he avoided the limelight as this article suggests. Webb ran BLE Realty and its marketing arm, the Venice Company. Eventually he built an estate home on West Venice Avenue, which still stands.

Ads like this appeared nationwide, and people from every section of America came to see the wonders at Venice. The Brotherhood had the wisdom of engaging creative minds to design and build the resort city. Skeptics were far and few between since America's oldest, largest, and richest union backed the project.

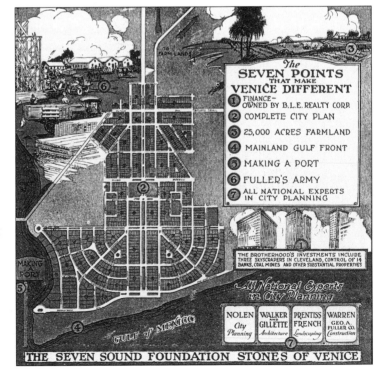

22

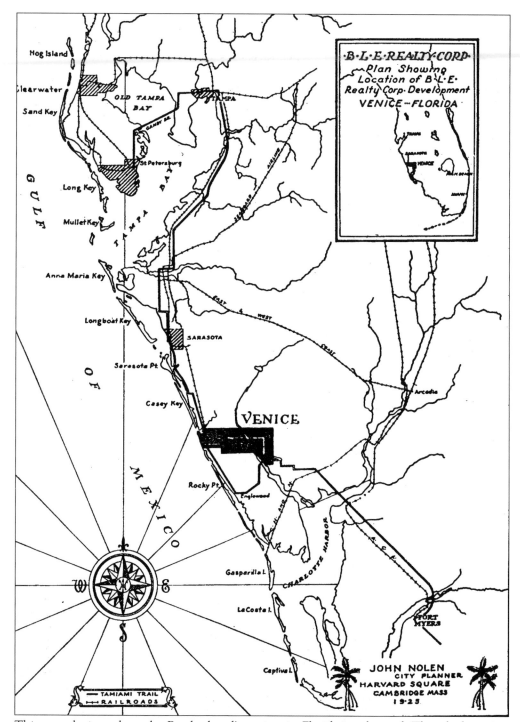

This map depicts where the Brotherhood's project in Florida was located. Though the union acquired some 30,000 acres at Venice, in the end, only a small portion was ever developed. This drawing was one of dozens prepared by the eminent city planner John Nolen.

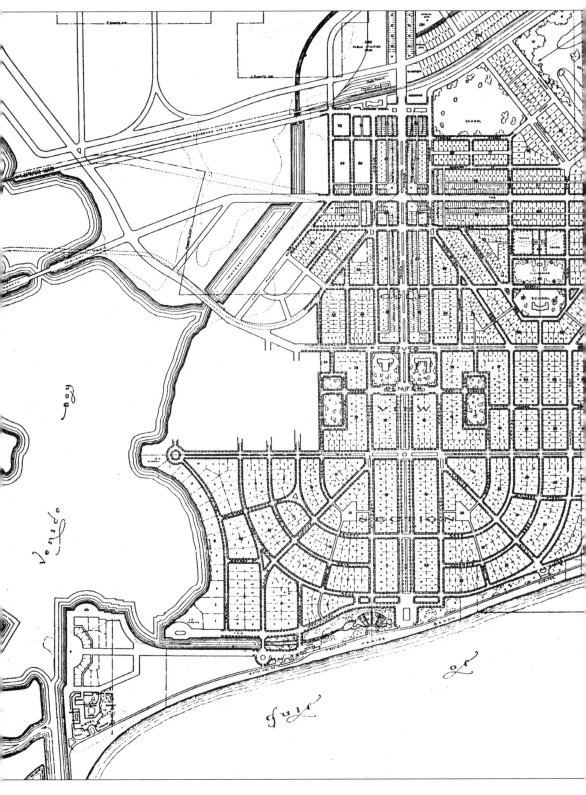

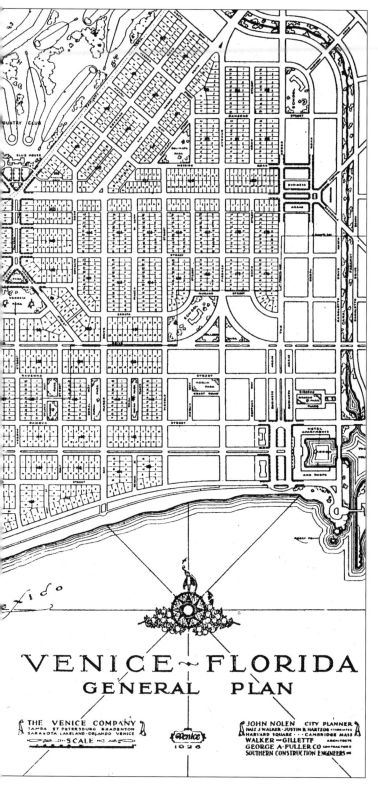

VENICE ~ FLORIDA
GENERAL PLAN

THE VENICE COMPANY
TAMPA ST PETERSBURG BRADENTON
SARASOTA LAKELAND ORLANDO VENICE
SCALE

Venice
1926

JOHN NOLEN CITY PLANNER
DALE J WALKER JUSTIN R HARTZOG ASSOCIATES
HARVARD SQUARE · · · CAMBRIDGE MASS
WALKER~GILLETTE ARCHITECTS
GEORGE A·FULLER CO CONTRACTORS
SOUTHERN CONSTRUCTION ENGINEERS

John Nolen's "General Plan of 1926" straightened the Tamiami Trail through Venice and relocated the Seaboard railway track 1/4 mile east of the city. Also, the golf course location differed from Dr. Albee's "Venice Beach" plan because a golf pro had pronounced the original site "too flat." The main east-west artery (Venice Avenue) ran from the Seaboard station to the Gulf beach. Curvilinear streets graced the left half of the plan, and the "void" represents land that the union could not acquire. Hotels materialized, but not at Casey Pass (lower left) or Rocky Point (lower right). First-time visitors still marvel over Venice's friendly street system.

25

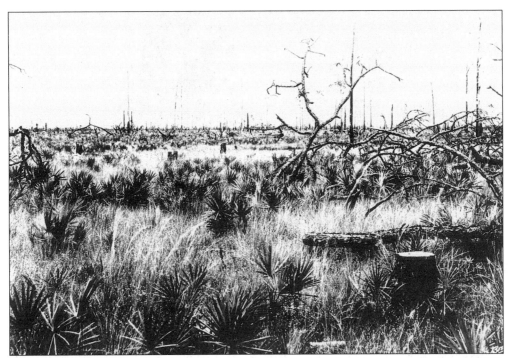

Most of the Brotherhood land in Venice looked like this when it was purchased in 1925. Logging had occurred in many places, and countless acres had been burned by lightning storms. After a careful survey, grubbing began, followed by excavation and grading.

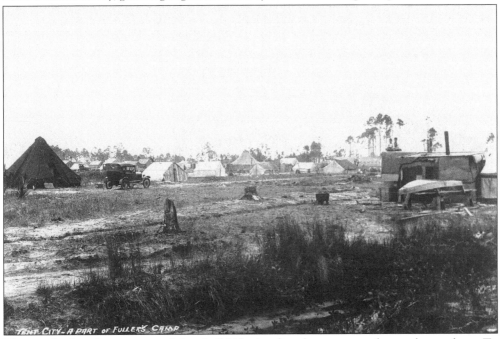

Thousands of workers were needed to build Venice, but there was no place to house them. To remedy this, Fuller Construction established a camp south of Hatchett's Creek and called it "Tent City."

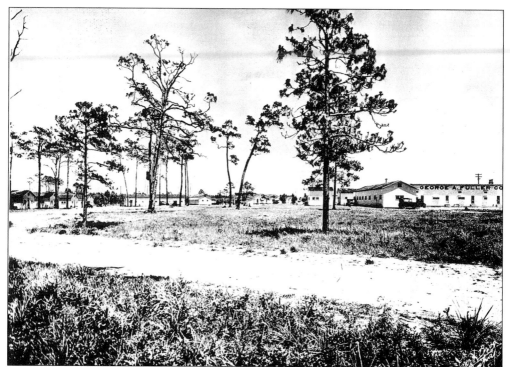

Fuller Construction buildings housed supplies, materials, cars, trucks, and tractors. Bunkhouses were built, as well as eight-room company homes, providing two rooms for each family. The complex above was located northeast of where St. Augustine Street and Nokomis Avenue met. The city's water tower—a Venice landmark for decades—is behind one of the trees.

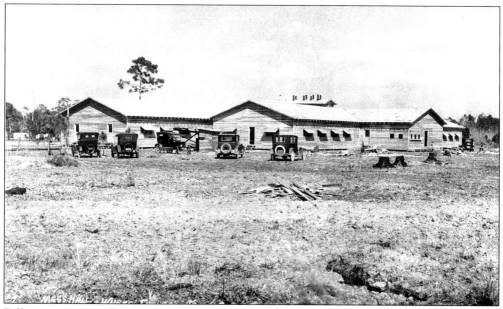

Fuller's army ate at the mess hall seen here, and a private contractor ran the commissary. Three thousand workers could be fed in a single hour. Many Fuller employees walked to work, but cars, buses, and tractors also performed jitney duties.

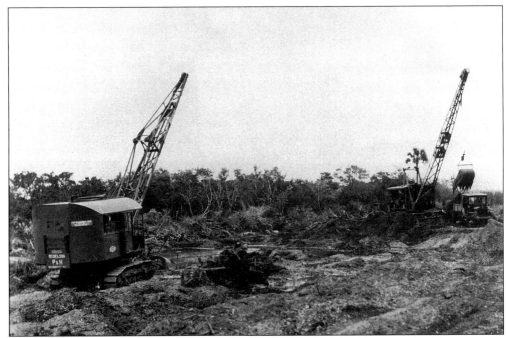

Draglines were essential for grubbing, as this image confirms. Stumps and brush were burned, and what remained was hauled away and dumped elsewhere. Occasionally, shell deposits were uncovered and reclaimed for street building.

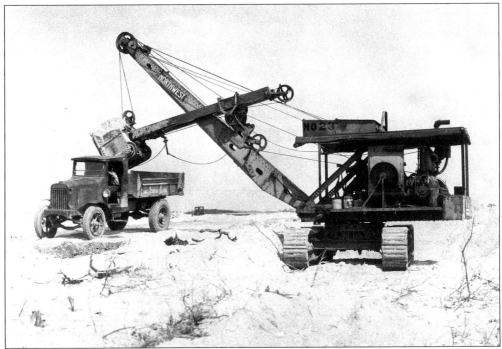

A power shovel loads shell into a dump truck in this March 1926 scene. Once compacted, the shells made an ideal base for streets. Fuller employed a separate workforce just to keep such apparatus in running shape.

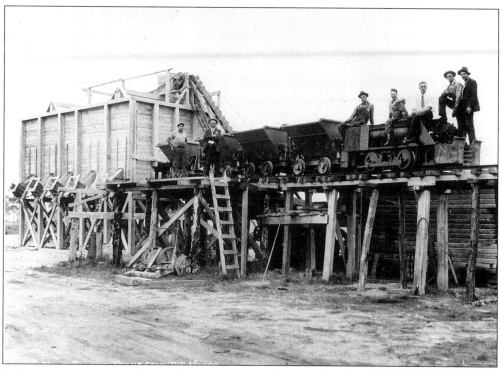

Sedimentary rock existed in shallow quarry near Venice proper and made its way to the "crusher" thanks to a small industrial railroad. A gas-engine locomotive pushed the hopper cars up the track and the stone was unloaded. Then, it was pulverized and used as a building material.

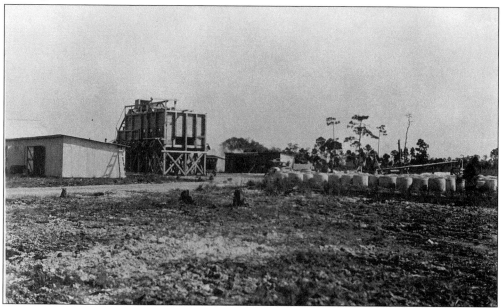

The backside of the crusher, seen in the previous image, has come into view. The building materials that the crusher created were used in several products, such as the concrete storm sewer pipe seen at the right.

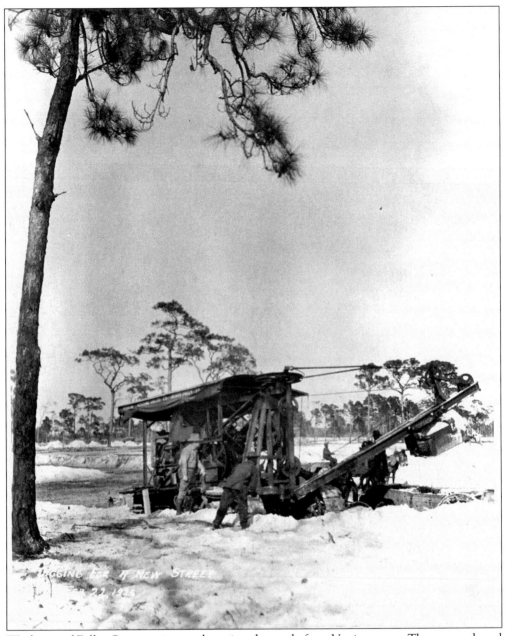

Workmen of Fuller Construction are lowering the grade for a Venice street. The power shovel is carving up the land and dumping spoils into a mule-drawn wagon. The animal's head can be seen just below the bucket.

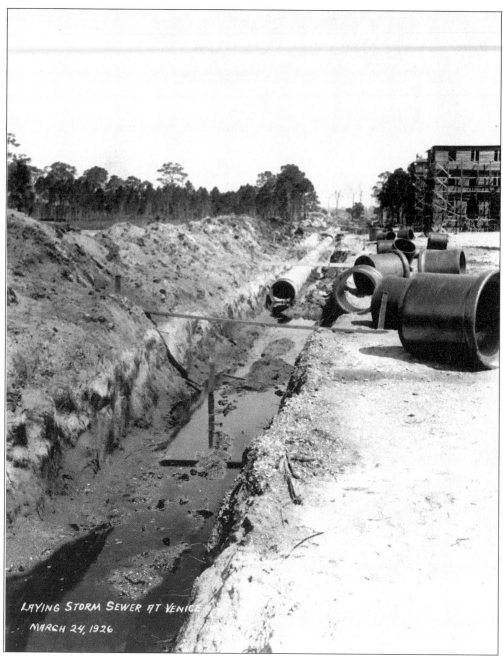

LAYING STORM SEWER AT VENICE
MARCH 24, 1926

Storm sewer pipe has now been delivered to street side and awaits installation. Unlike many Boom projects in Florida, the Brotherhood insisted that proper infrastructure be installed prior to the construction of any home or building.

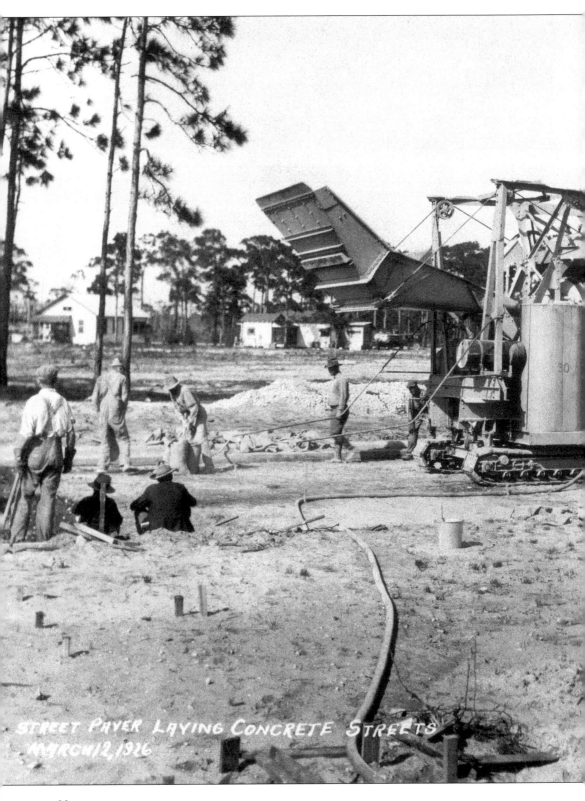

STREET PAVER LAYING CONCRETE STREETS
MARCH 12, 1926

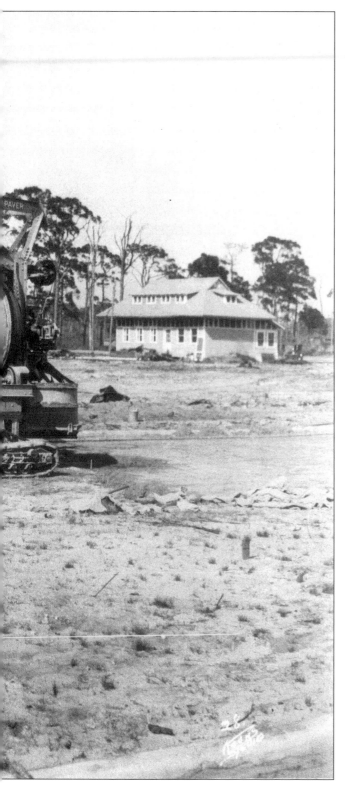

Fuller's paving machine was a mechanical monster. Materials for concrete were placed in the scoop, which was then raised, allowing ingredients to slide into the revolving drum. Water was added and—presto!—an 8-inch-thick concrete street was poured. About 850 square yards were laid each day. Later, a 1-inch-thick layer of Kentucky Rock asphalt was applied to the top of the street and "roughed up." The building at the far right, located on the east end of Tampa Avenue, was the original hotel that Bertha Palmer built to accommodate prospective land buyers. It was also used by Seaboard train crews.

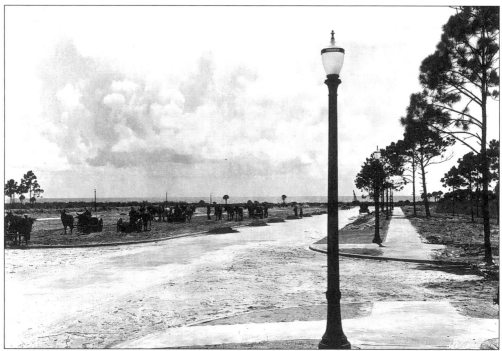

Nearly a dozen mules harnessed to rollers and grass cutters can be seen in this Venice Avenue image. Staggered piles of clippings lie on the broad boulevard. The Gulf lay beyond.

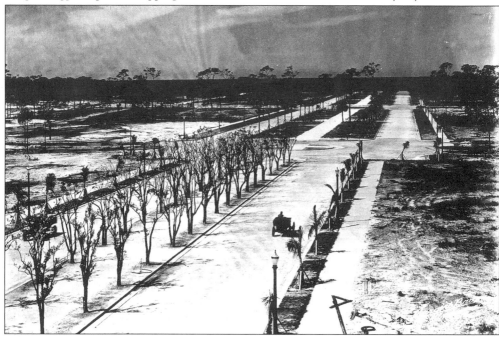

Venice Avenue was the main artery through the resort city and cost $250,000 to build. It was 200 feet wide in the residential district (120 feet in the business area) and boasted an 80-foot parkway (bridle path) down its middle. Citrus trees were planted down each side of the parkway, while sidewalks got live oaks and date palms.

At the behest of John Nolen, the Brotherhood engaged Prentiss French as their project's landscape architect. French had graduated from Harvard's School of Landscape Architecture and was related to Daniel Chester French, who sculpted the Lincoln Memorial. Prentiss hired a staff of 50 in Venice, made up of designers, plantmen, and seedmen.

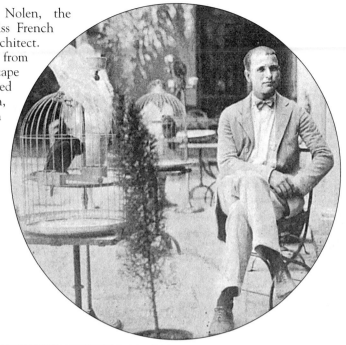

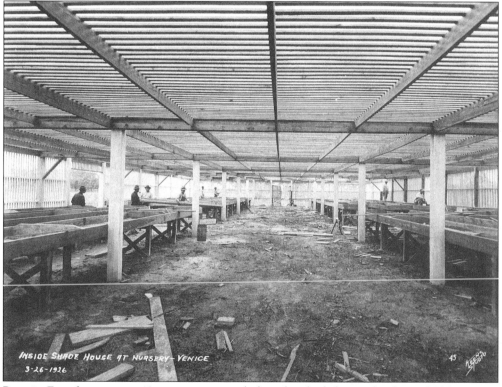

INSIDE SHADE HOUSE AT NURSERY - VENICE
3-26-1926

Prentiss French oversaw a 40-acre nursery, including this shade house that housed 300 varieties of plants, coming from such faraway places as Japan and Madagascar. There were also sheds, a lath house, storage facilities, cottages, and a complete water system.

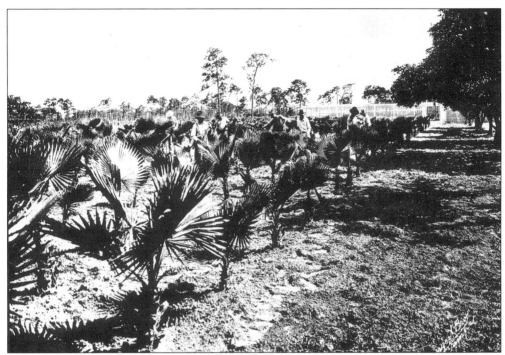

All manner of palm trees, from Sabal to Royal, were raised at the Brotherhood's nursery, and numerous hands were needed to nurture them. This was a far more cost-effective method than having such trees imported.

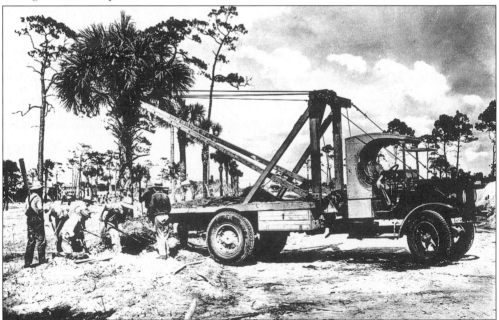

This White Motor truck aided French's workforce in the planting of palm trees. The boom gently lowered a tree into position and then steadied it during final planting. The visible presence of African-American laborers confirms their valuable role in the original creation of Venice. Wages ranged from $3 to $4 a day—good pay in 1926.

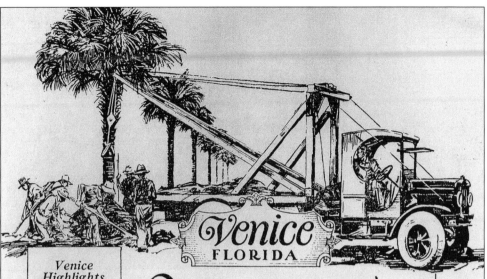

Venice
FLORIDA

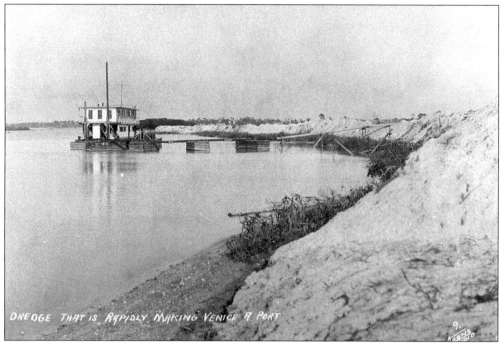

DREDGE THAT IS RAPIDLY MAKING VENICE A PORT

Dredging operations at Casey's Pass (Venice Inlet) and Venice Bay (Roberts Bay) always drew spectators. By June 1926, a channel 1,700 feet long, 185 feet wide, and 10 feet deep was ready for vessels wanting to enter from the Gulf, but a deep-water terminal was never built.

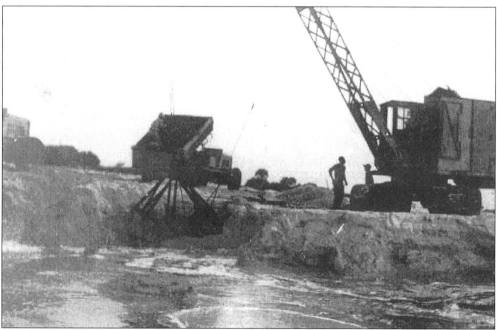

Shell sand was excavated as a construction material from both Casey's Pass and Treasure Island (Casey Key). In this October 1927 scene, the mighty power shovel loads awaiting trucks at the tip of Treasure Island. (Florida's State Photo Archive.)

Three

HOME SWEET HOME

More and more people these days want ideal living conditions without needless expense. They want good schools, libraries, ample parkways, recreational space, architectural regulations that protect against atrocities, and lots large enough to have a little breathing space.

—City Planner John Nolen

Nolen wanted each Venice neighborhood to have its own identity yet be part of a cohesive, overall plan. To help achieve this goal, Nolen advocated the use of deed restrictions ("safeguards") like the ones he had proposed for Dr. Albee's Venice-Nokomis project. Restrictions included rules such as only one dwelling per family; each dwelling could have a single garage or a greenhouse; no business enterprises or signs or fences were allowed; and the sales of real estate could only occur to persons of the Caucasian race. Cats and dogs were, of course, permitted, septic tanks were a must, and each dwelling was to have underground garbage receptacles.

To ensure that homes blended architecturally, the supervising architects of Venice, Stewart Walker and Leon Gillette insisted that all structures exhibit Northern Italian characteristics (known as the Mediterranean Revival style), which called for tiled sloping roofs, stucco exteriors, and colorful awnings. Prohibited were flat roofs, gaudy colors, and unusually rough plasters. Prior to construction, the plans had to be approved by Howard Patterson, the firm's resident architect.

The Mediterranean Revival style raged all across the southern United States during the 1920s. It tapped into a romantic spirit, the exotic and faraway, and played the past against the present. Spanish imagery became exceedingly popular, and movie stars like Charlie Chaplin, Rudolph Valentino, and Douglas Fairbanks lived in Spanish-inspired estates. Arched openings, heavy wooden doors, loggias, quatrefoil windows, and domed bell towers were common, as were massive fireplaces, courtyards, and fountains. Some homes even boasted mini-balconies and iron-grilled windows. Inside, the visitor would see exposed beams and tiled floors. Imported tapestries were hung on walls, and many rooms were decorated with imported antiques and heavy furniture.

In November 1925, Southern Construction Engineers platted the first subdivision in Venice. Called "Gulf View Section," the subdivision was located between the Seaboard track and the Gulf of Mexico. Within its boundaries was the city's commercial district, the most expensive lots, several parks, as well as the mainland beach. Lot prices ranged from $5,000 to $30,000, while commercial parcels cost $100 per frontage foot.

The public saw the infant city for the first time in February 1926. Special trains were run to Venice from Tampa, St. Petersburg, Orlando, and other Florida points. Thousands attended the event, including Governor John Martin, and a giant barbecue was staged at the beach. Lot sales were conducted from the Venice Bathing Pavilion. Visitors also had access to the Fuller Construction complex. Barracks and garages were thrown open to the public, as well as machine, carpentry, and paint shops. Draglines and heavy equipment were displayed, and tours were made to Casey's Pass to see the huge hydraulic dredge. By mid-1926, the first construction phase of Venice had been completed.

"Venezia Park District," another residential subdivision, centered on a trapezoid-shaped park that was framed by the intersecting streets of Nassau, Salerno, and Sorrento. Many superb homes were built here. The homes themselves, as in Gulf View Section, were built by private contractors, who erected them on either speculation or a custom-built basis. To stimulate construction, the Venice Company announced in July 1926 that the Brotherhood had established a $6 million loan fund to aid Venice homebuilders.

Gulf View and Venezia Park attracted middle- and upper-income homebuyers, but something less prestigious was needed for the union's rank and file. George Webb asked John Nolen to create a new subdivision that had moderately priced lots with very few deed restrictions. In March 1926, Southern Construction Engineers filed a plat (east of the railroad) called "Edgewood," whose gridiron consisted of 50-by-150-foot lots priced from $850 to $1,600. One-story homes in the neighborhood would sell for $2,500. Country Club Parkway was Edgewood's main north-south artery, and in January 1927, the area was formally annexed to the City of Venice.

Newcomers who relished apartment living were not overlooked in the Nolen plan. In "Armada Road District," there arose a collection of multi-family dwellings in the Mediterranean Revival style. For instance, ten apartment buildings were constructed by Tampa builder M.G. Worrell at $38,000 apiece. Other complexes arose in the city, including the $200,000 Worthington Apartments built at the corner of The Rialto (Tamiami Trail) and Palmero Place.

As the following photographs confirm, all manner of housing was built in Venice during the Brotherhood era, from simple bungalows to Spanish-styled estates. Thanks to John Nolen, a friendly network of streets connected the various neighborhoods and beautiful parks were within easy walking distance.

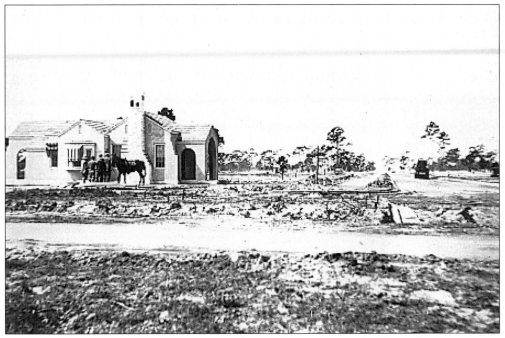

BLE Realty's first office in Venice was located on Nokomis Avenue, but later, the structure was moved to St. Augustine Avenue. After June 1926, offices were established at the union-owned Hotel Venice.

Howard Patterson was the resident architect of the New York firm Walker & Gillette. His approval was needed on home and building plans, which had to meet Northern Italian design criteria. Today that criteria compose what is known as the Mediterranean Revival style.

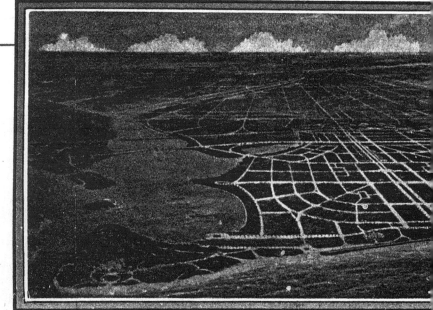

Advantages

No keys or islands to interrupt the view.

A beach with all the security of the main-land.

Elevation—fifteen feet above Gulf.

High dry land.

On the Tamiami Trail about 15 miles south of Sarasota.

Venice is bein
what you would lik
by America's master

City Planning

HIS highly important phase of development is under the supe
vision of John Nolen & Associates of Cambridge, Mass. The beautiful ci
plan now being worked out has been conceived by this organization ar
provides an excellent background for the architectural and building project

Landscape Engineering, etc.

The beautification of the streets, boulevards and parks of Venice is und
the direction of Prentiss French, graduate of the Harvard School of Landscape Arc
itecture. He has just returned from a three months study of landscape engineerin
in Mediterranean countries. The best that Europe offers in the way of attracti
settings for homes will thus be available to residents at Venice.

Promotional literature was prepared by the Venice Company, including this bird's-eye view
which looks east. The careful reader can discern the main east-west artery through the city—
Venice Avenue.

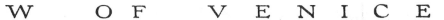

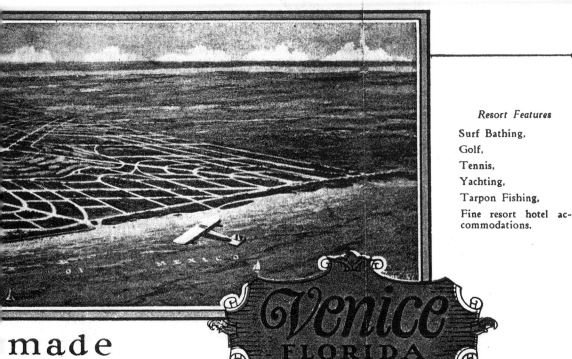

Resort Features

Surf Bathing,

Golf,

Tennis,

Yachting,

Tarpon Fishing,

Fine resort hotel accommodations.

made
t to be
uilders

Building Construction

The George A. Fuller Company of New York and Chicago are in charge of construction. They are responsible for the execution of the imposing improvements which will make Venice one of Florida's outstanding resorts.

Architectural Expression

The beauty and harmony of Venice's Italian architectural expression is the work of Walker & Gillette, eminent architects of New York City. The brilliant creative capacity of this organization finds in Venice a rare opportunity for expression. The result will be an architectural triumph.

Through this combination of creative ability, Venice's parks and boulevards, playgrounds, yacht basin, golf course, lagoons and hotels will make this city the resort supreme of Florida's West Coast.

43

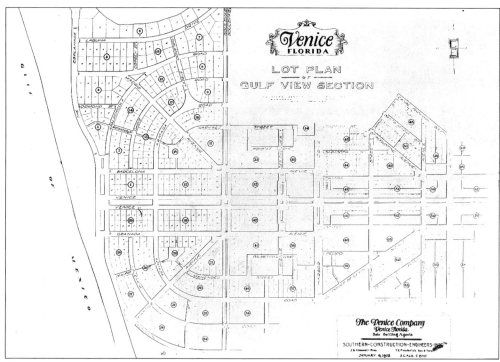

Southern Construction Engineers filed its plat of Gulf View Section in November 1925. Lots were sold in two separate promotions, and it was several months before the area's infrastructure was completed by Fuller Construction.

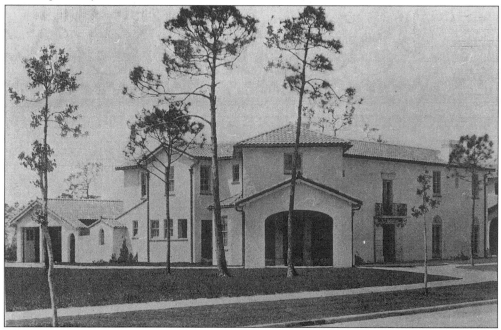

Substantial homes appeared in many areas of Gulf View Section, and this one at 605 West Venice Avenue was custom-built for BLE Realty executive George T. Webb. Like many Brotherhood-era homes, it still stands.

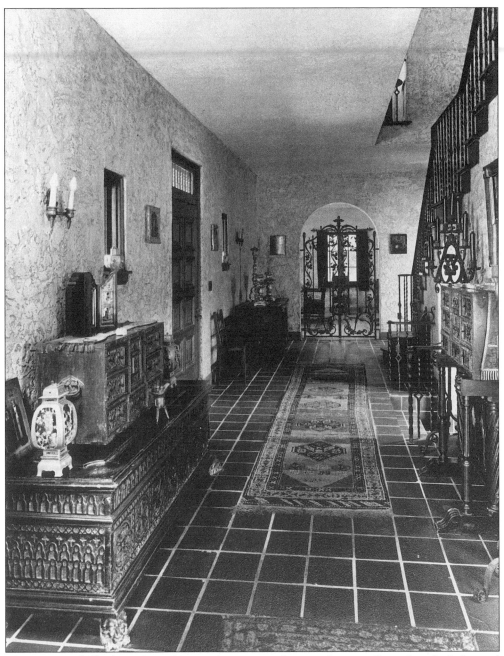

The entrance hall of 613 West Venice Avenue was decorated in true Spanish style. It boasted tiled floors, oriental carpets, imported antiques, and large pieces of carved wooden furniture. Ornate iron gates led to the dining room.

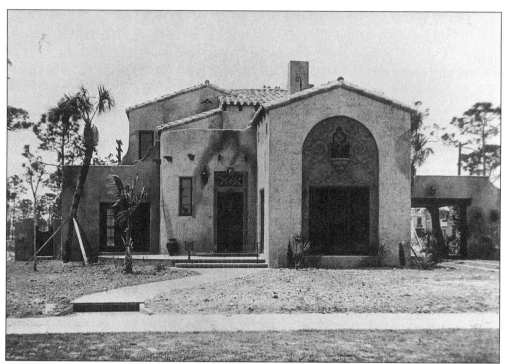

A Mediterranean Revival masterpiece was built at 625 West Venice Avenue, and Jay Brown, the official photographer of the Venice Company, snapped this image in 1926. Red barrel tile was used on the low-sloping rooflines.

Gulf View Section was also comprised of smaller Spanish-styled homes, such as this one-story example at 326 Pedro. Colorful canvas awnings provided shade, and a two-bay garage complimented the property.

This two-story home at 229 Harbor Drive South had a rough-cast stucco exterior, and at the right gable is a round, slatted attic vent. A tradesman is applying the finishing touches to the screened arcaded loggia, or gallery.

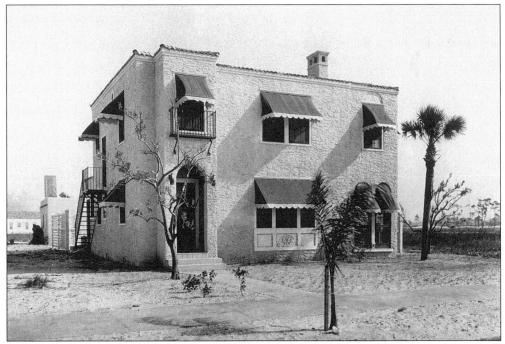

A wrought-iron balconet adorned this two-story residence at 241 Harbor Drive South. The home had a covered portico front entrance and a screened arcaded loggia. The foundation was of concrete block.

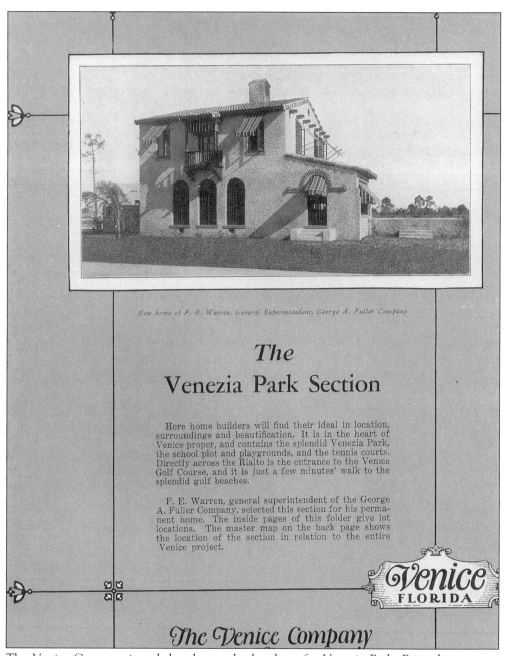

New home of F. E. Warren, General Superintendent, George A. Fuller Company

The
Venezia Park Section

Here home builders will find their ideal in location, surroundings and beautification. It is in the heart of Venice proper, and contains the splendid Venezia Park, the school plot and playgrounds, and the tennis courts. Directly across the Rialto is the entrance to the Venice Golf Course, and it is just a few minutes' walk to the splendid gulf beaches.

F. E. Warren, general superintendent of the George A. Fuller Company, selected this section for his permanent home. The inside pages of this folder give lot locations. The master map on the back page shows the location of the section in relation to the entire Venice project.

Venice
FLORIDA

The Venice Company

The Venice Company issued the above sales brochure for Venezia Park. Printed on orange paper, the promotional piece included a street grid plus a pricing schedule for lots.

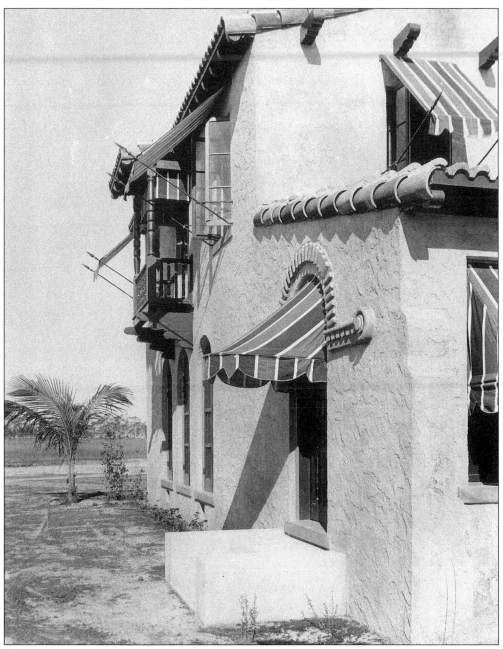

This is the same home seen in the previous image, but its Spanish details are more visible. The second-floor balconet was made of turned wood. The owner of the residence was Frank Warren, the superintendent of the Fuller Construction Company.

This one-story classic at 333 Sorrento Street featured a screened porch and a beautifully capped chimney. Multi-colored roof tiles are clearly visible but not the home's two-car garage.

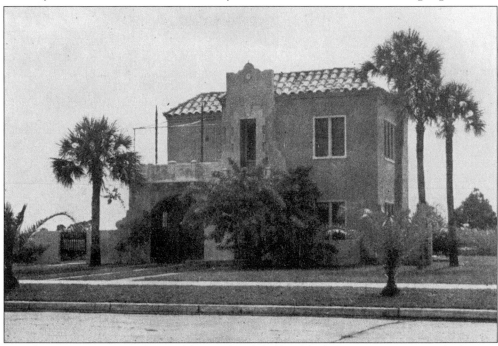

Most homes in Venezia Park were fabricated with hollow block; however, some were built using poured concrete such as this one at 508 Ponce de Leon. Recently planted palm trees and vegetation appear in this 1927 view.

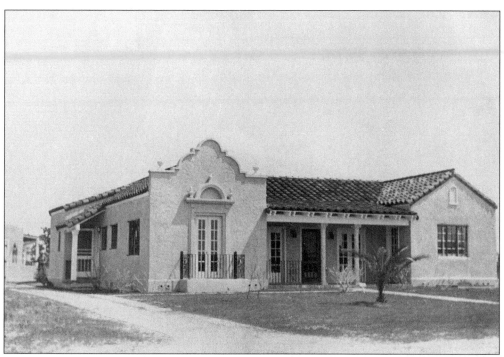

The screened center porch was a definitive feature of 224 Salerno Place, as were the concrete reliefs, columns, and brackets. The house was built on a concrete slab and had a wood-frame structural system. Wood casement windows were utilized, and the exterior finish was rough-cast stucco.

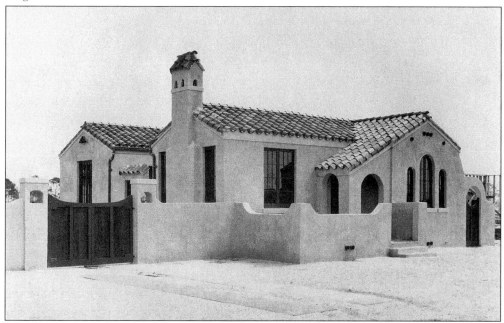

Venezia Park homes were far from monotonous, as this one story, U-shaped structure at 405 South Nassau Street confirms. An open, arched porch faced west and a large fireplace graced the living room.

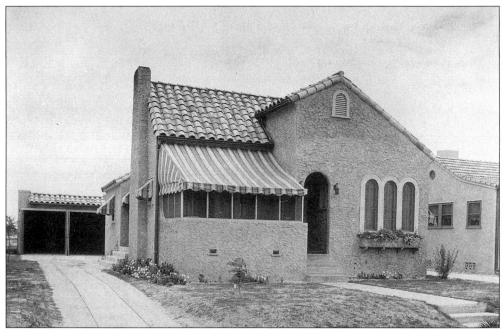

This home at 239 Pensacola Road resembled the one in Gulf View Section on the bottom of page 46. A colorful awning overhangs a screened porch, and the home's recessed entranceway is visible along with a triple-arch window.

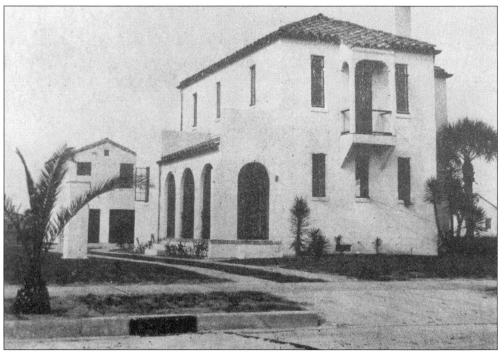

Our brief tour of Venezia Park concludes with this elegant home at 540 Riviera Street, built in 1927. A balconet graces the second-floor bedroom, and an apartment can be seen over the garage.

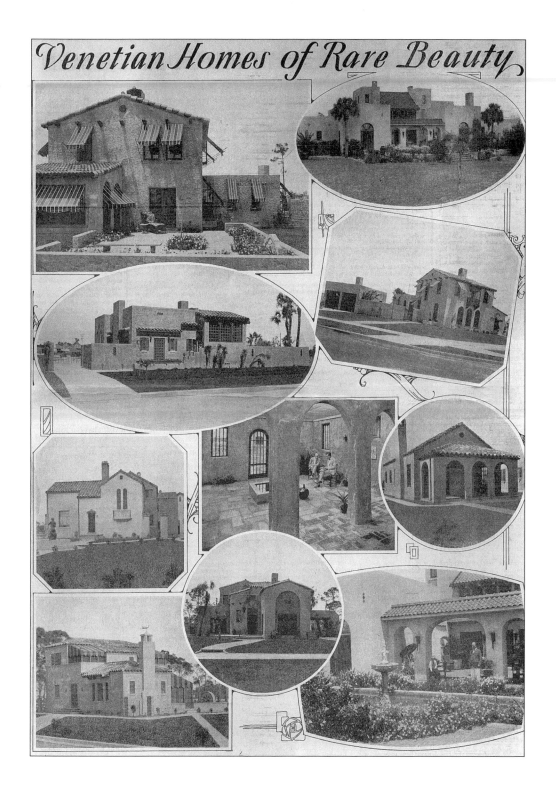

East of the Seaboard Railway track lay the Edgewood Section, conceived by planner John Nolen with both residential and industrial components, though each were marketed separately. Homes were not intended for the wealthy but for the Brotherhood's rank and file.

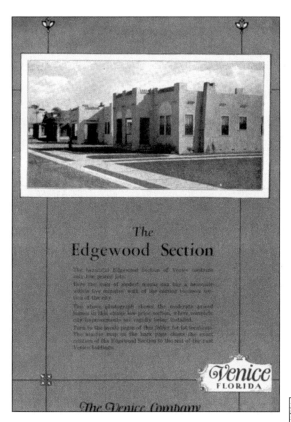

Platted by Southern Construction Engineers, Edgewood was "for those who came to Venice to earn a living and make a permanent home," said Brotherhood president William Prenter.

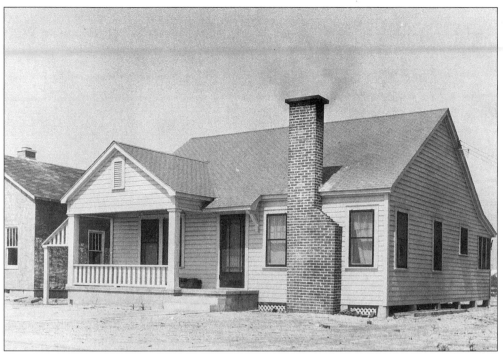

This Groveland Avenue residence in Edgewood used asphalt shingles, brick, and clapboard. A porch provided shade from the hot Florida sun.

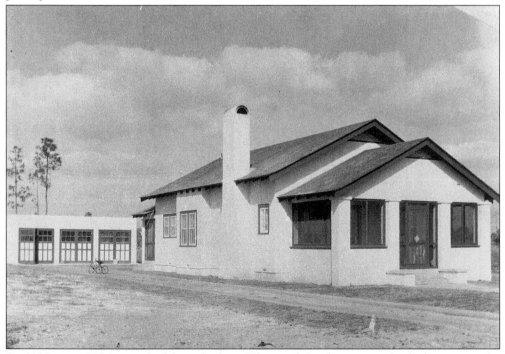

By 1928, over 100 homes had been built in Edgewood. In this image, shrubs have yet to be planted at 833 Groveland Avenue. Capped vertical columns can be seen, as well as a generous screened porch and a stucco, capped chimney. Note the three-car garage!

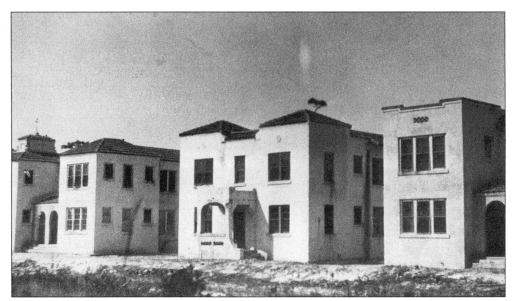

A splendid collection of apartments was built in the Armada Road "Multi-Family District," and its focal point became John Nolen Park. Most structures in this area have survived and remain unaltered. Tampa builder M.G. Worrell fabricated this trio.

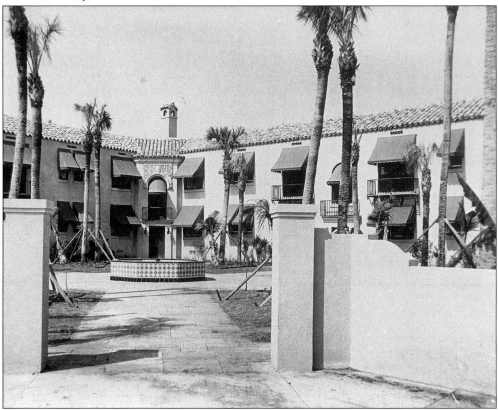

This inviting apartment complex, built in 1926, was located at the corner of The Rialto and Palermo Place. Its owner was a Brotherhood officer and Venice's first mayor, E.L. Worthington.

Four

HOTELS

The wonders of Venice were advertised throughout the nation by the Venice Company. The marketing subsidiary of BLE Realty also wrote publicity articles about the "City By the Gulf" that appeared in travel and tourist brochures, Brotherhood publications, and the company newspaper in Venice. Shortly after advertising and publicity campaigns were launched, visitors began to arrive in Venice by car, bus, and train. Single folks appeared as well as couples, families, and groups. Upon their arrival, they were greeted by Venice Company salespeople, who paraded them about while reciting well-rehearsed sales scripts. But there was a tiny problem for those who had come from afar: the ready-made city lacked a hotel. As a temporary measure, Venice Company guests were placed in homes and hostelries outside the city. In fact, many were dispatched to Sarasota—a distant 18 miles away—where several city hotels existed. But as more and more prospects poured in from around the country, accommodations became even more problematic. The number of guests needing rooms became difficult to predict, often rooms in the region quickly sold out, and transportation had to be available to distant points at odd hours. What the resort city needed was a hotel of its own, one that could accommodate sales prospects, Brotherhood officials, as well as future tourists and vacationers.

Certainly there was no better candidate to develop a hotel than the Brotherhood itself. After all, a renowned architectural firm was at its disposal along with one of the country's largest construction firms. Thus, in January 1926, the union announced that it would erect a $500,000 structure at the intersection of Tampa and Nassau Streets. Hotel Venice was designed in the Italian Renaissance style by New York architects Walker & Gillette. The three-story, 100-room building was started in March by George A. Fuller Construction and, amazingly, opened 90 days later. It would also house Brotherhood offices.

But the need for hotel accommodations proved far greater than what union officials first estimated. Shortly after Hotel Venice opened, the Brotherhood announced that another structure would be constructed on West Venice Avenue on the site of today's post office. Hotel Park View used the same basic plan as Hotel Venice and it, too, was sped to completion within three months by Fuller Construction. Then, ground was broken for a third hotel! R.W.

Wishart, a popular Tampa contractor, built the $350,000 San Marco Hotel, today's Venice Centre Mall. Architect Franklin Adams, president of the Florida State Association of Architects, drew up the plans for the 92-room, three-story building, which opened in December 1926. Sixteen retail stores were located at street level.

Smaller hostelries were also constructed in Venice during the Brotherhood era. The 56-room Venezia Hotel on Nokomis Avenue was developed by Franklin Wheeler of Fort Myers. The Myakka Hotel in turn graced The Rialto (Tamiami Trail). Stanton Ennes, general manager of the Venice Company, built the Valenica Hotel, which featured an arcade and retail shops. One of the most unique buildings in all of Venice was the Triangle Inn, which boasted two loggias and a castle-like turret. John Nolen's 1926 "General Plan of Venice" called for resort hotels to only be built at Casey's Pass (Venice Inlet) and Rocky Point (near today's airport), but these were never constructed. It is not known if the eminent planner approved or disapproved of the sites the Brotherhood chose for its three hotels. Regardless, the new hostelries provided much-needed accommodations.

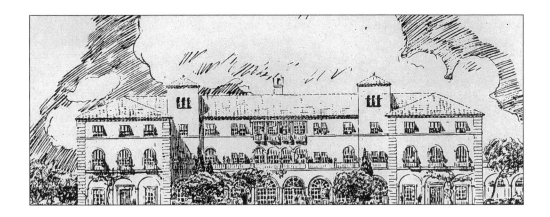

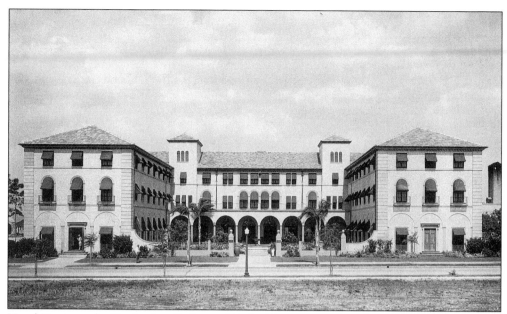

Hotel Venice—the Brotherhood's first public building—opened on June 21, 1926. It was built to accommodate sales prospects of the Venice Company, but it also housed the offices of that firm. Numerous social events were held at Hotel Venice, and its orange grove dances became legendary.

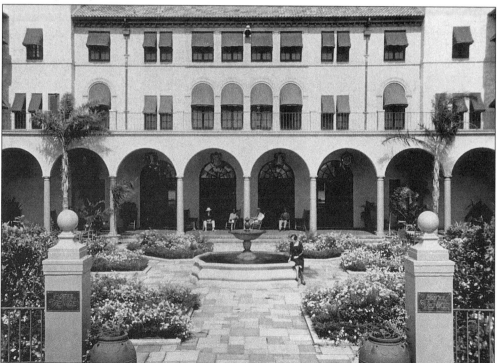

An inviting courtyard greeted Hotel Venice guests. Plantings came from the union's nursery and were arranged by Prentiss French. Harold Heller, a French staffer, designed the fountain. The building still stands and is occupied by a retirement home called Park Place.

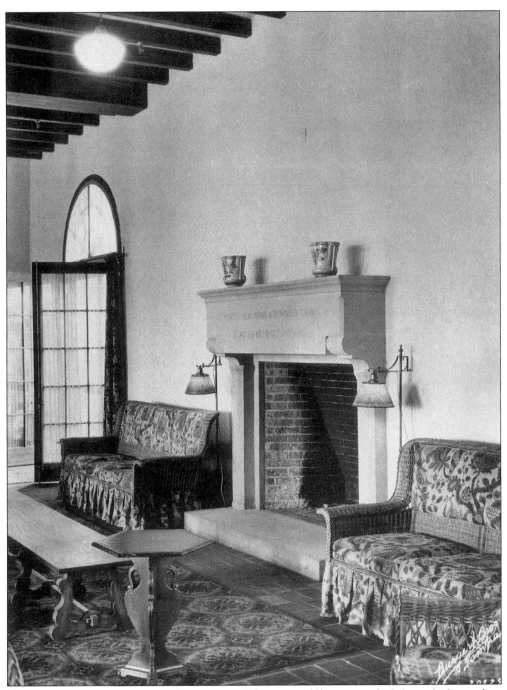

Many rooms in Hotel Venice had cypress wood beams. Gulf breezes wafted through the reading room, and on chilly days, the doors were closed and the fireplace was lit. The following inscription was embedded upon the mantle: If youth knew what age would crave, it would both get and save.

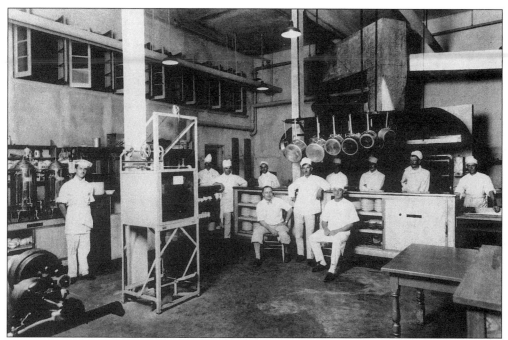

Members of the kitchen staff of Hotel Venice pose for the cameraman in 1926. Giant copper pans and crockery are visible but not the kitchen's refrigerator, which was the size of a railroad boxcar. Wait staff brought food to a dining room measuring 69 by 38 feet.

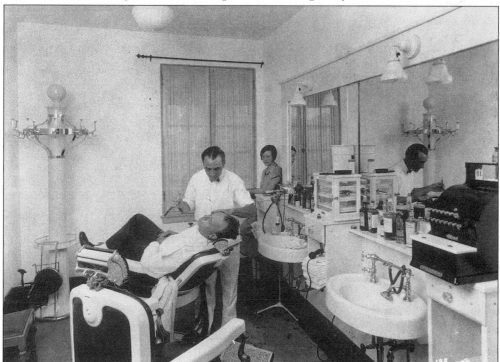

Getting a daily shave was *de rigeur* for many Hotel Venice guests. The cost? Perhaps just $1 as the cash register window shows. A manicurist stands at the ready.

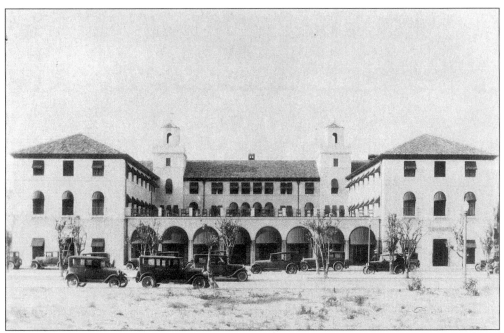

The roof towers of the Park View Hotel differed from Hotel Venice. After the Brotherhood vacated Venice, Dr. Fred Albee bought the Park View Hotel and converted it to the Florida Medical Center. In the 1960s, it was demolished for the new post office.

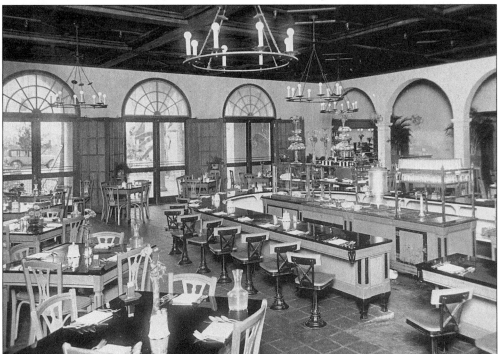

Lunch anyone? The coffee shop at Park View Hotel is ready to serve in this 1926 view. Its wood-beamed ceiling is visible, as well as the immaculate tiled floor. The dining rooms of Brotherhood hotels also attracted residents and travelers.

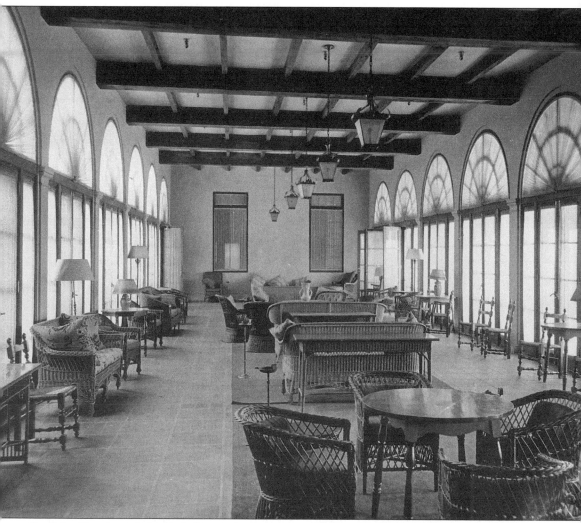

Sunlight illuminated the Park View's reading room. Wicker furniture was in vogue, and the doors were frequently left opened for a cool ocean breeze. Guests could plunk down with a good read, play cards, or just snooze.

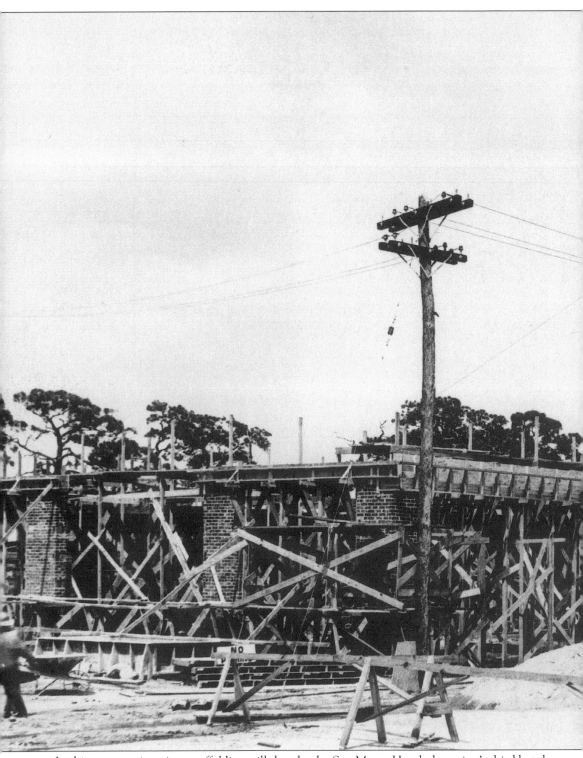

In this construction view, scaffolding still sheaths the San Marco Hotel, the union's third hotel. Doors opened on December 10, 1926. After the Brotherhood's departure, the building was

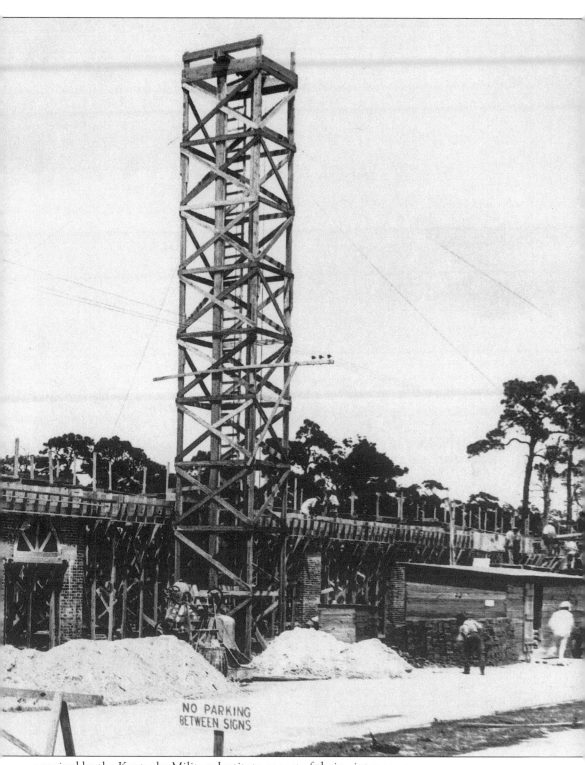

acquired by the Kentucky Military Institute as part of their winter campus.

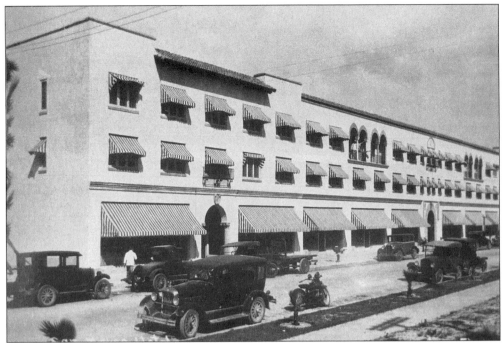

Striped awnings shade the windows of the newly completed San Marco Hotel. The hostelry offered special packages and reduced rates to sales prospects visiting Venice. Today, Venice Centre Mall calls the building home.

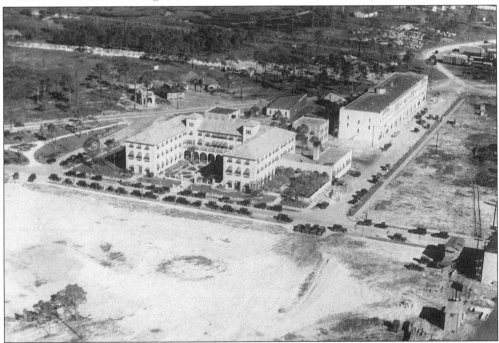

Aerial photographs recorded construction progress. In this easterly view, one can see the U-shaped Hotel Venice and the rectangular San Marco Hotel. The old Seaboard railroad station lay beyond, as well as the barracks and buildings of George Fuller Construction Company.

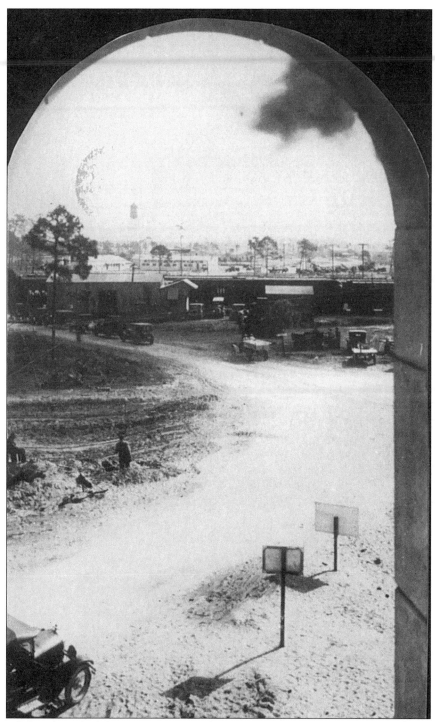

A second-floor portal of the San Marco Hotel frames the shed-like Seaboard railroad station at Tampa Street and Nokomis Avenue. Fuller Construction buildings are beyond, as well as the famed water tower—a Venice landmark for decades. Very soon the Seaboard will relocate its facilities farther east.

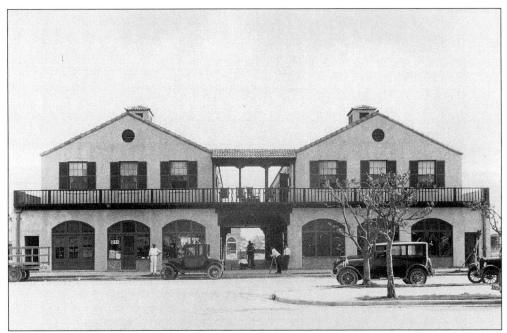

The Valencia Hotel, owned by Venice Company official Stanton Ennes, was one of several small hostelries that emerged during the Brotherhood era. The Venice post office was among the building's tenants, and later the facility became known as El Patio.

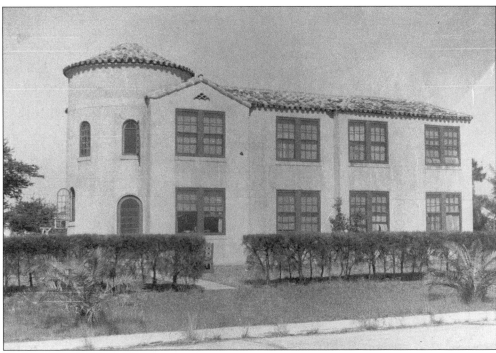

Built by Augusta Miner, the Triangle Inn was first located at 251 Nassau Street. In 1991, the bed and breakfast was moved to 351 South Nassau Street, where it now houses the city's historical agency—Venice Archives and Area Historical Collection.

Five

COMMERCE AND

INDUSTRY

Much of John Nolen's creative output reflected "Garden City" ideals, i.e. small cities, an agricultural-industrial economy, and protective greenbelts. Land uses were carefully defined, and Nolen's 1926 plan for Venice was no exception. Specific areas were set aside for homes, hotels, parks, schools, harbors, and farms. Never did the eminent planner expect that Venice would be built in one fell swoop. Rather, he anticipated that the city would unfold as the population expanded, perhaps to 10,000 souls.

It was in the vicinity of Venice Avenue and The Rialto (Tamiami Trail) that John Nolen conceived the commercial or business district of Venice. Once the sites had been prepared, parcels of land were marketed by the Venice Company to developers and business owners. An architect was usually engaged to design a building. Plans, of course, had to conform to Walker & Gillette architectural guidelines, but once they were approved, construction could begin. Most of the buildings constructed were two-story structures of block and steel with stucco exteriors. Many had large plate glass windows set in either round arches or rectangular openings. Second floors often featured balconies and round arched windows. Canvas awnings were also popular, and several buildings had recessed entranceways, decorative spandrels, or twisted columns.

The first commercial building in the district was begun in May 1926. In time, banks, general merchandise stores, and fine shops appeared, and many of these businesses prospered when Brotherhood hotels were filled to capacity. By early 1927, the business sector also included a pharmacy, grocer, furniture store, electrical company, tea room, hardware outlet, haberdasher, barber shop, newsstand, and five-and-ten-cent store. A chamber of commerce and a Venice merchants association promoted business interests.

From the beginning, John Nolen insisted that the Seaboard railroad track be relocated 1/4 mile east of the new city. Brotherhood executive George T. Webb got Seaboard president S. Davies Warfield to agree to the plan because the union promised to pay for all relocation and new station costs. It was near the new Seaboard complex, on a triangular tract, that Nolen created an industrial park for Venice. Lots here ranged in price from $3,200 to $4,000. Firms

that eventually erected buildings in the area were chiefly those that supplied construction materials for the resort city, such as a tile company, lumber yards, brick works, a plumbing supply outfit, and a concrete products manufacturer.

On July 1, 1926, the only permanent building in the city was Hotel Venice, but by year's end, 185 buildings were under construction or being completed, an investment of over $3 million. From a tiny hamlet, Venice quickly grew into a community of 3,000 people. In December 1927, the "City By the Gulf" became a true Florida city, and Governor John Martin named Edward L. Worthington its first mayor. All council members including Worthington were Brotherhood development officials.

During 1926 ownership of BLE Realty Corporation shifted to the Brotherhood's Grand International Division in Cleveland. Many union officials were now questioning Webb's activities and the enormous expenses of creating the resort city, even though subsidiaries continued to make loans on the venture. To raise additional funds, a seven percent bond issue was floated. Though a Brotherhood advisory board prohibited any additional land purchases at Venice, in the summer of 1926 another 20,000 acres made their way into the books. Holdings now amounted to 53,000 acres—nearly 80 square miles! These storm clouds aside, the commercial and industrial district of Venice began to flower as the following images confirm. Insofar as Venice businessmen and area developers were concerned, the Brotherhood was moving "full steam ahead."

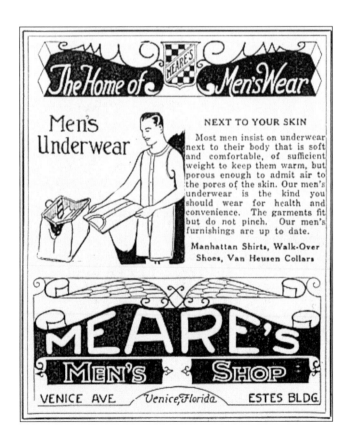

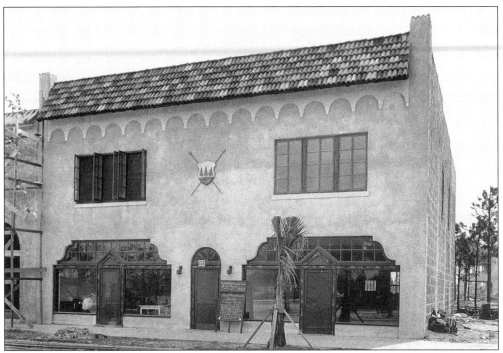

The Boissevain Building at 205 Venice Avenue was the resort city's first commercial building (other than its hotels). Two retail stores occupied the lower level; a billiard hall was planned for the upper. In recent years, the building was home to the Resort Shop.

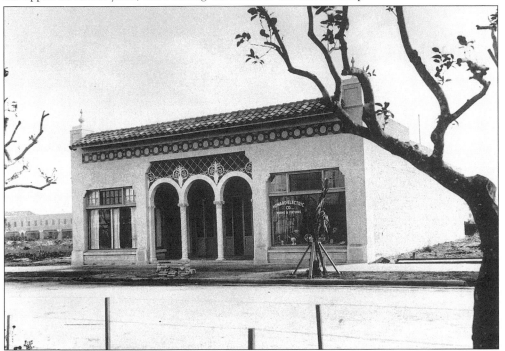

Twisted columns helped form the ornate entranceway to Howard Electric on 247 Venice Avenue. Bressler's Ice Cream and Venice Travel later became occupants.

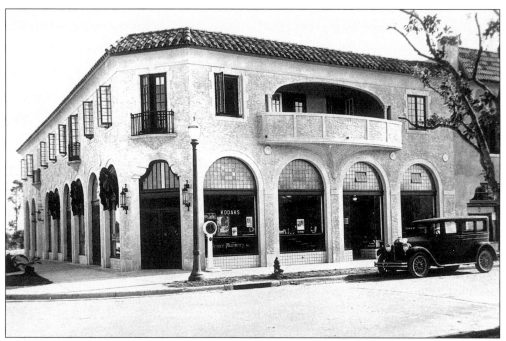

The Johnson Schoolcraft Building stood at Venice and Nokomis Avenues and boasted a balcony and balconets. Gulf breezes waft through the open casement windows. The first floor housed the Venice Pharmacy, which is pictured below.

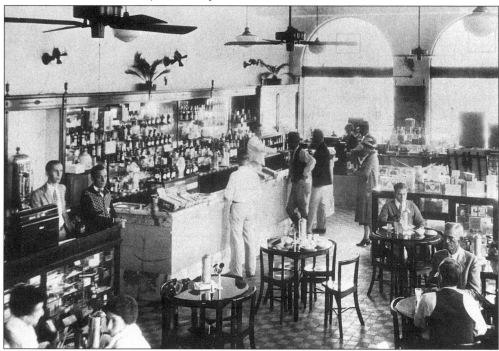

Business appears good at Venice Pharmacy in this 1927 scene. Pharmacopoeia was dispensed from the back left counter, and soda fountain concoctions from the right. Tobacco products were displayed in the stand-alone case.

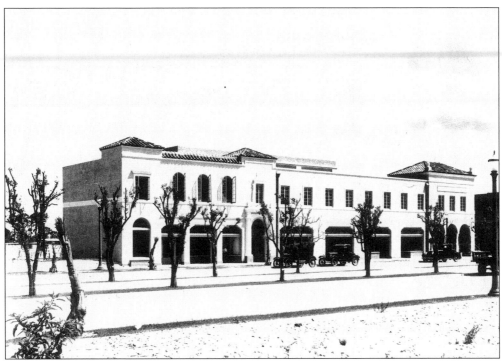

This four-lot, Venice Avenue complex was built by Newport P. Estes of Orlando for $175,000; Harrison Bell was the architect. The Gulf Theatre occupied the far right unit. The whole complex was demolished in 1969.

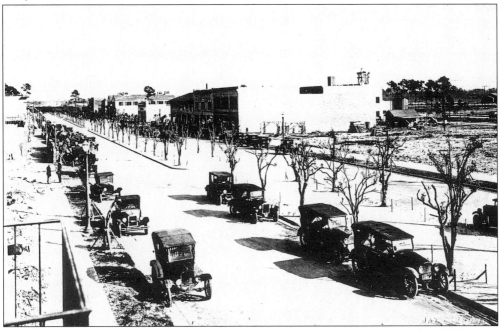

The commercial district of Venice Avenue is beginning to take shape in this 1927 scene photographed by Jay Brown. Orange trees define the parkway. Surprisingly, John Nolen dedicated few parking places for cars.

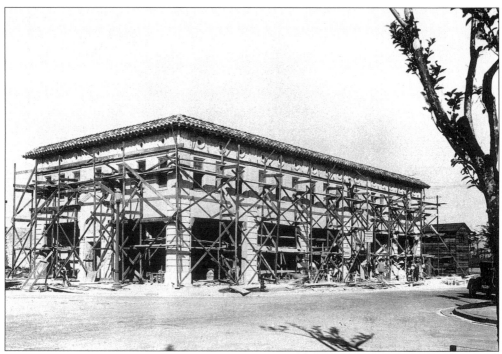

Dr. Fred Albee ran the Venice-Nokomis Bank, which was first located in Nokomis. In 1927, a new bank building, costing $75,000, went up on the corner of Nassau Street and Venice Avenue. After the Brotherhood vacated the resort city, Albee again became prominent in Venice affairs.

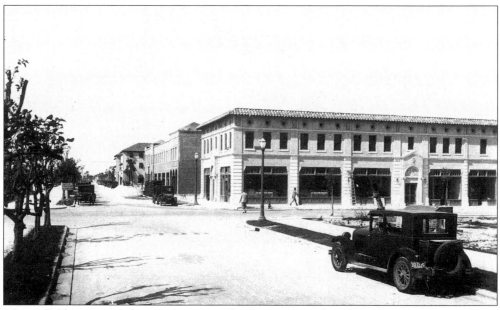

The scaffolding seen in the previous image has been removed, and finishing touches are being applied to Albee's bank. Venice Avenue melts into the background. Beyond the bank is the four-lot Gulf Theatre building previously seen on page 73. Beyond it is the Brotherhood's Park View Hotel.

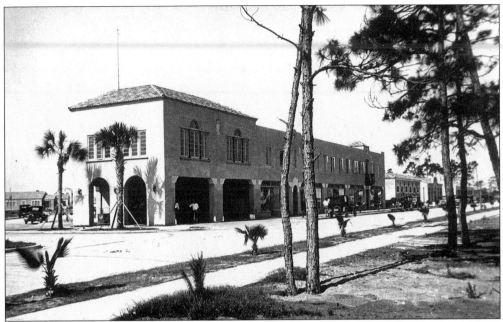

The triangle-shaped "Green Building," designed by Tampa architects Gill & French, was built at the corner of Miami and Ponce de Leon Avenues. A filling station occupied the east end of the flatiron structure and shops to the west. Upstairs were ten apartments. Today, the building is known as Burgundy Square.

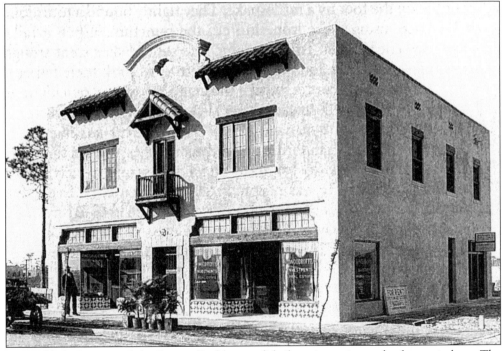

A wood balconet graced the Sawyer Building as did tile wainscoting under front windows. The edifice, located at 312 West Miami Avenue, housed Woodroffe Investments as well as Harry Sawyer's grocery store and meat market.

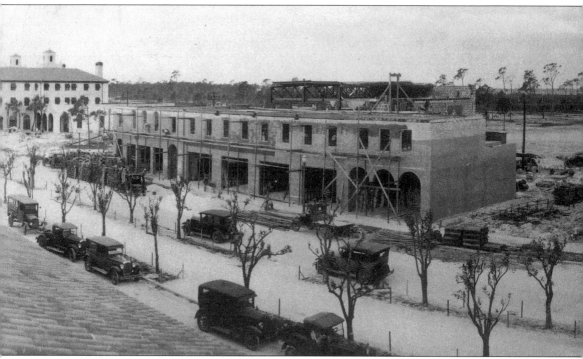

In this image, the camera's fish-eye lens gently distorts an otherwise straight Venice Avenue. At far left is Hotel Park View, followed by the Gulf Theatre building, and then Dr. Albee's Venice-Nokomis Bank. Nassau Street interrupts and leads north to Hotel Venice. To the right of Hotel Venice is the San Marco Hotel. Other Venice Avenue commercial buildings (see

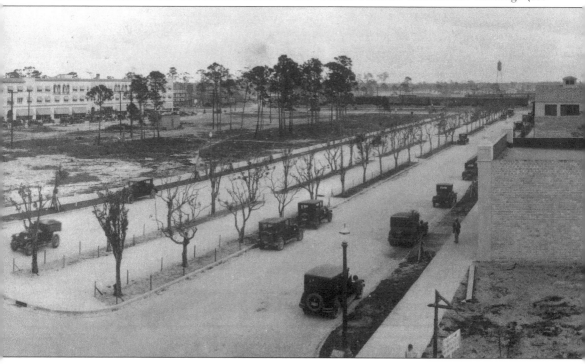

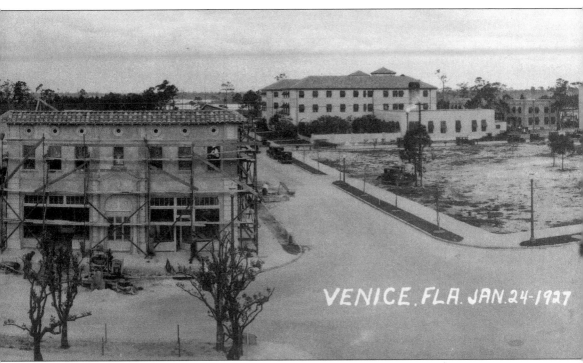

below) are in the center right foreground, and in the distance is the famed Venice water tower. Angled at the very far right are Miami Avenue structures. The triangle-shaped Green Building is at the cluster's left side.

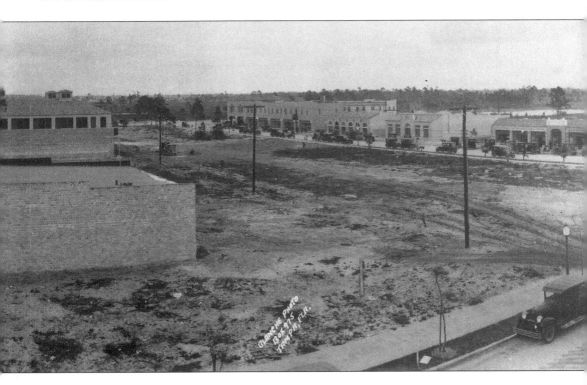

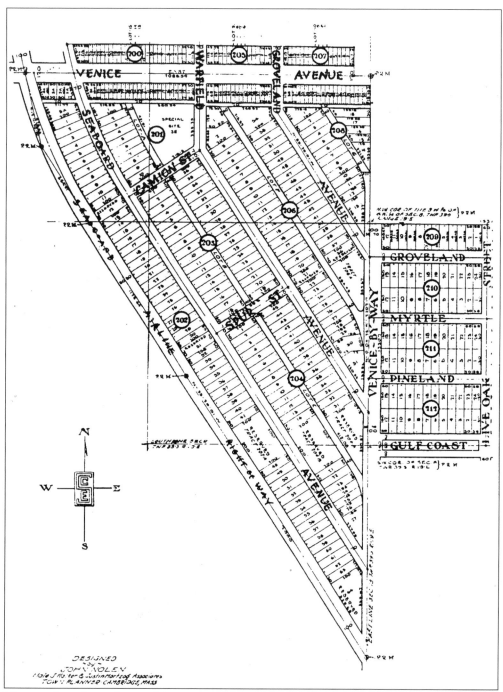

Edgewood was located east of the resort city, and John Nolen designed it with both residential and industrial sectors. The Venice Company marketed each component separately. Then, as now, industrial firms inhabit the triangular tract, and a street is named for railroad president S. Davies Warfield.

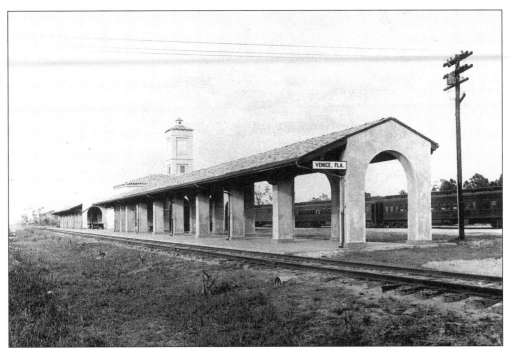

Architects Walker & Gillette designed Venice's current station, which opened March 27, 1927. Local building materials were used; timbers came from Brotherhood land. The $48,000 structure, funded by the union, had a campanile tower, but a clock face was never installed.

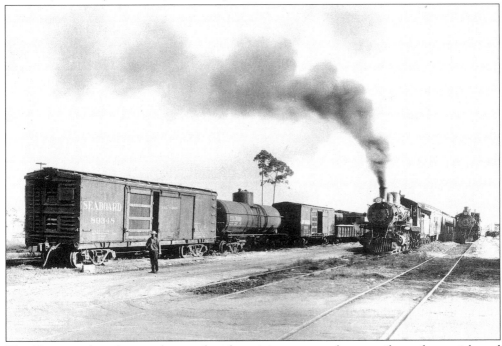

The Venice rail yards once hummed with activity, as countless manifests of materials and supplies arrived to build the resort city. In this 1927 scene, a local passenger train gets underway for Sarasota. A ventilated boxcar for perishables is at far left.

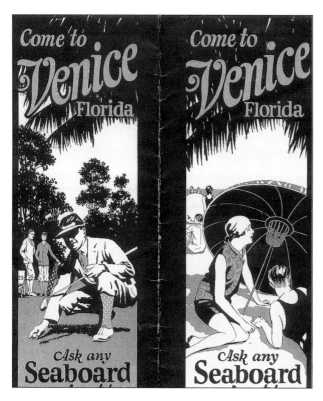

The Seaboard Air Line Railway profited from Boom-era traffic, and colorful literature was prepared to describe the Florida communities that the company served. The example here covered a 15-panel brochure printed in aqua blue, orange, and green. The copy, of course, was supplied by the Venice Company.

Ask Any

SEABOARD

AGENT

or write directly to the

Venice Chamber of Commerce

VENICE, FLORIDA

THROUGH SLEEPING CARS OPERATED YEAR ROUND FROM
NEW YORK, PHILADELPHIA, WASHINGTON
AND BALTIMORE TO VENICE

CAROLINA-FLORIDA SPECIAL
Effective Dec. 16 to Jan. 2, Inclusive.

Lv. New York	(PRR)	3:10 pm
" W. Philadelphia	"	5:13 pm
" Baltimore	"	7:24 pm
" Washington	(RF&P)	11:00 pm
" Richmond	(SAL)	2:20 am
" Jacksonville	"	11:10 pm
Ar. Sarasota	"	9:00 am
" Venice	"	10:30 am

FLORIDA WEST COAST LIMITED
Effective January 3.

Lv. New York	(PRR)	7:10 pm
" W. Philadelphia	"	9:23 pm
" Baltimore	"	11:26 pm
" Washington	(RF&P)	12:40 am
" Richmond	(SAL)	4:00 am
" Jacksonville	"	11:10 pm
Ar. Sarasota	"	9:00 am
" Venice	"	10:30 am

SUWANNEE RIVER SPECIAL
Year-round train solid between Cincinnati and the West Coast of Florida.
Through sleeping car Cincinnati to Venice.

Lv. Chicago	(Big Four)	1:00 pm
" Cleveland	"	3:40 pm
" Detroit	(Mich. Cen.)	12:05 pm
" Cincinnati	(Southern)	9:50 pm
" Atlanta	"	1:15 pm
Ar. Sarasota	(SAL)	9:00 am
" Venice	"	10:30 am

ORANGE BLOSSOM SPECIAL
Overnight limited solid Pullman between New York, Washington and the Florida West Coast
Effective December 6.

Lv. New York	(PRR)	9:30 am
" W. Philadelphia	"	11:35 am
" Baltimore	"	1:50 pm
" Washington	(RF&P)	3:10 pm
" Richmond	(SAL)	6:27 pm
Ar. Plant City	"	4:45 pm
Lv. Plant City	"	5:00 pm
Ar. Sarasota	"	7:55 pm

Through sleeping cars New York to Plant City. Parlor car from Plant City to Sarasota and connection by bus at Sarasota for Venice.

Essential to any railroad brochure was a map, which oriented travelers and showed the ease of connections. Sleeping car service to Venice was available but in short supply during the Boom. Train names and schedules appear at right.

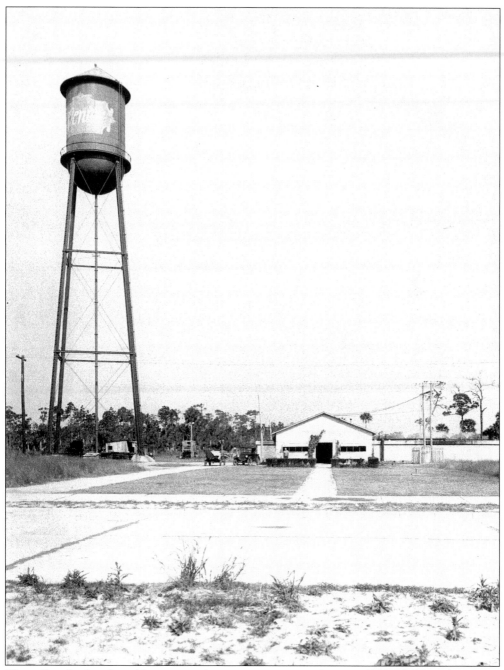

The tallest landmark in Venice was the water tower, seen here in 1928. Unlike other Boom projects in Florida, the Brotherhood equipped its resort city with water right from the start. At ground level (near the tower), Fuller Construction created a 500-gallon-per-minute pumping facility from four artesian wells.

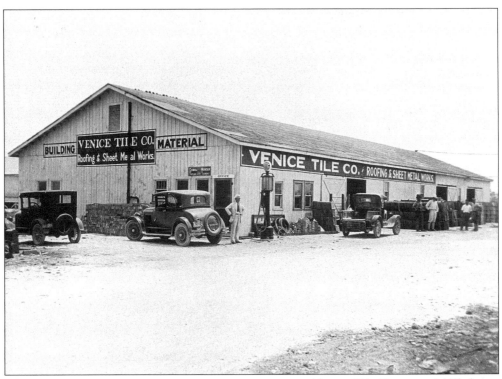

Venice Tile Company fulfilled roofing, floor, and decorative requirements with distinction. E.R. Jahna, from Bohemia, ran the 5,000-square-foot operation, and it was the first structure in Venice's industrial park.

OLD WORLD WORK SHOP

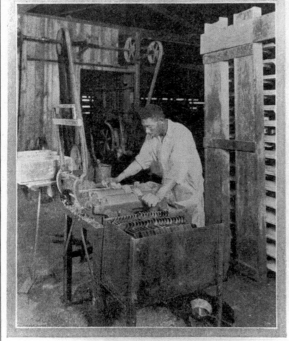

New tile for old, would be an appropriate title for this picture, which shows a workman turning out ancient tile on a modern machine.

Venice Tile Company used old-world techniques. Here, a concrete roof tile is coaxed into shape by a machine and workman.

Six

FARMING THE LAND

The Brotherhood of Locomotive Engineers began its Florida venture in 1925 by purchasing 30,511 acres of Venice land, though only a small portion of the plat was actually needed to create the resort city. Most of the tract was located between the city and the Myakka River, and it was in this area that the union established its farm program.

The "Venice Farm Plan" was an important component of John Nolen's regional vision. Almost anything could be grown in the semi-tropical climate of Venice, especially truck, or vegetable crops that could mature in 100 days or less. Two yields a year were possible, and Nolen foresaw the day when farms would help feed the hungry city, as well as provide foodstuffs for Northern markets. To reach Venice Farms, a hard-surfaced road was built from Venice to the farm district. Dozens of 5- and 10-acre farm sites were platted in this tract; then each was cleared, fenced, drained, plowed, and disked. Several artesian wells were dug in the region for irrigation purposes, and a cover crop was planted on each new farm site prior to the owner's arrival. The first cover crops were planted in May 1926, and sales of Venice Farms sites began a month later. A typical 10-acre parcel sold for $450 an acre and was advertised as suitable for growing peppers, potatoes, eggplants, watermelons, squash, peas, beans, cucumbers, or strawberries. A small, furnished farmhouse could be erected on the property for $2,500, and a chicken house and barn could be supplied for $1,000. A deep well could be had for $500, and a new tractor would cost the same amount. Thus, one could become a turnkey farmer for about $10,000.

In addition to selling farm sites, the Brotherhood dedicated 80 acres of land for experimental vegetable farms, strawberry and poultry demonstration farms, and a model dairy. Albert Blackburn, a former ranch hand to Bertha Palmer, who helped the Brotherhood acquire its Venice land, became the manager of the demonstration facilities. A farm board, organized by the union, provided valuable information and assistance to new farm owners, many of whom had no prior farming experience.

Of no little significance was the Brotherhood's dairy operation, which was located 6 miles east of the resort city. Here, a 160-acre site was fenced and cross-fenced into 25-acre plots.

A large, ventilated dairy barn was built that could accommodate 100 cows; 300 could be milked daily in relay fashion. The barn was fitted with expensive steel equipment, the finest milking machines, and the creamery and bottling plant was one of the most modern in the South. Operations began with a herd of 100 purebred Guernseys.

Pamphlets of the Venice Company extolled the fertility and profitability of Venice land. "One Man and Ten Acres" and "Pay Dirt! Venice Farms Florida" helped convince prospects that a comfortable living could be made in truck farming, though nothing was mentioned about how demanding and uncertain the business could be. The farms themselves were sold in several promotions. The first sales unit consisted of 1,429 acres. Later, North Venice Farms (1,924 acres) went on the market. To help arouse interest, a detailed model of a Venice farm was prominently displayed in the lobby of Park View Hotel. In September 1926, *Florida Grower* magazine dedicated an entire issue to the Brotherhood's farm operations. Then the Associated Press ran a promotional piece in December 1927 that featured Leigh Powell, the president of Seaboard Air Line Railway. Powell (business suit and all) had gone into the Venice fields to pick strawberries, where just the year before only pine and palmetto trees stood. On balance, the Venice Farm Plan was a unique ingredient of the Brotherhood's resort city, as the following images help confirm.

Horace K. Haldeman helped oversee the Brotherhood's operations at Venice Farms and authored several promotional articles about the project. Though much was achieved, several farm purchasers later sued the union because the land yielded little and drainage systems were never finished.

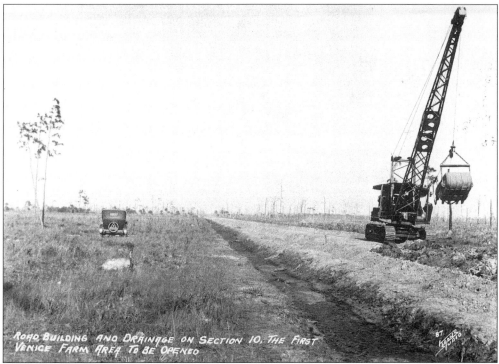

To reach the Myakka River, a crew of 400 men built the 12-mile long Venice Farms Road (later Venice Avenue East). Power shovels and draglines aided in the work, which also included the carving of a drainage ditch. The road was completed in 90 days.

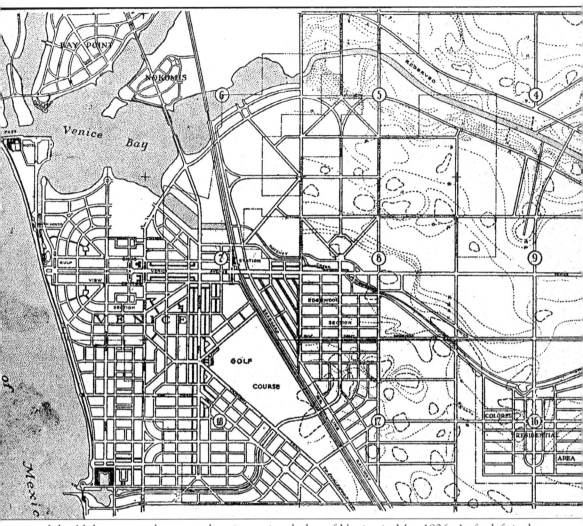

John Nolen prepared a comprehensive regional plan of Venice in May 1926. At far left is the resort city and golf course, followed by the triangular-shaped industrial district and the residential area of Edgewood. At far right is Venice Farms. A boat-traffic canal through Venice Farms, terminating at the Myakka River, never materialized, nor did the "Colored Residential Area" proposed in the center foreground.

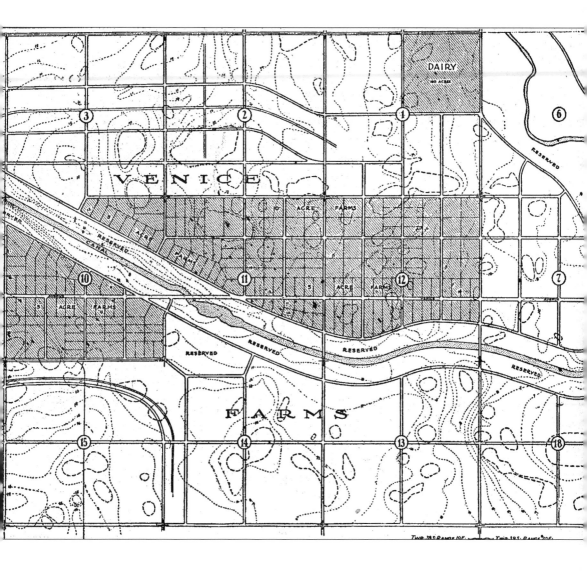

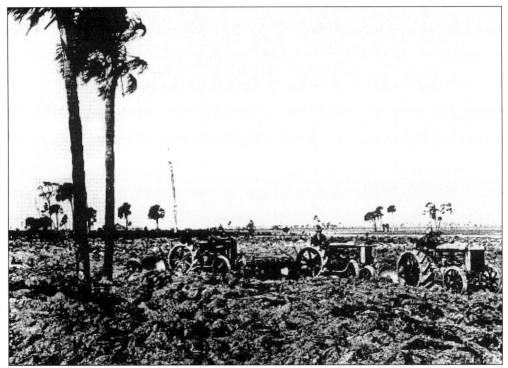

Pine and palmetto trees dotted the Venice Farms landscape. After grubbing and stumping, Fordson tractors appeared on the scene to plow and disk the land—sometimes in convoys as seen here. Later, a cover crop was planted for the purchaser. (Florida State Photo Archives.)

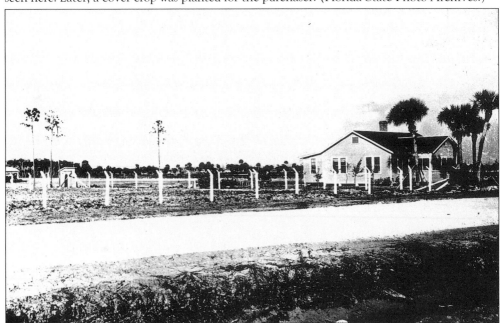

Modest, one-story frame houses were erected along Venice Farm Road and typically sold for $2,000. For another $500 furnishings could be supplied. What the outhouse cost (at far left) has not been learned.

Advertisements for Venice Farms appeared in dozens of newspapers, and the code number on the clip-off coupon identified which one. Here, farm facts are recounted as well as a math formula. The latter was probably true if the hand of nature cooperated and purchasing markets were at the ready. If not—lookout!

89

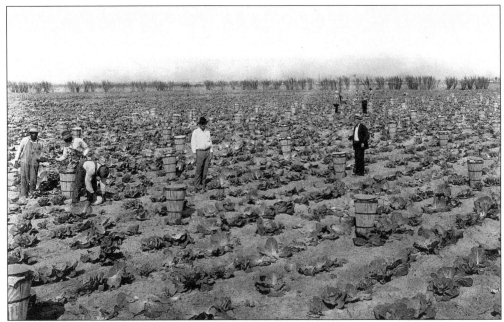

Workers are picking cabbage on the BLE's vegetable demonstration farm and placing heads into barrel-like crates. Later, the yield will be brought to the packinghouse, then rail shipped to northern markets.

A variety of vegetables were grown at the BLE's demonstration farms. Here, a truckload of green peppers has just been harvested. After a trip to the packinghouse, it's back to the fields.

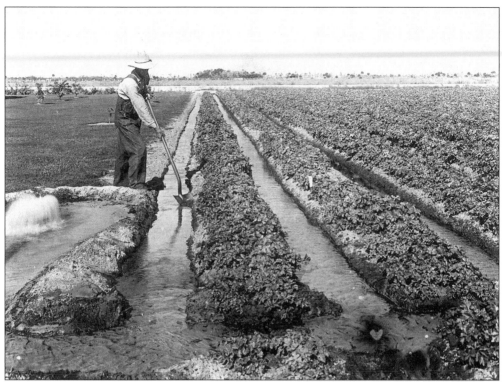

Victor Simmons directs water to celery rows at a BLE demonstration farm east of Venice. Artesian wells were dug for irrigation purposes, and one bubbles at left.

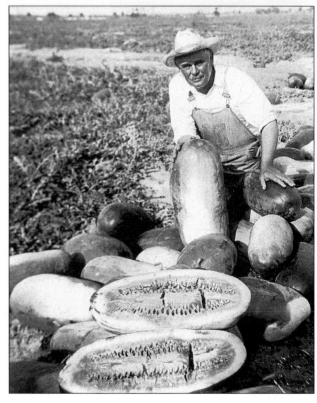

Farmer M.S. Roberts shows us how well watermelons grew in Venice soil. This anytime treat is still grown throughout Southwest Florida.

Mule-drawn wagons and Ford flatbeds arrived at the BLE's loading dock, which was located near the dairy. Inside, yields are carefully packed, then sent to the Seaboard railroad freight house in Venice for shipment to northern markets. Crates of eggplants can be seen at far left.

Year-round Poultry and Dairy Farming at Venice

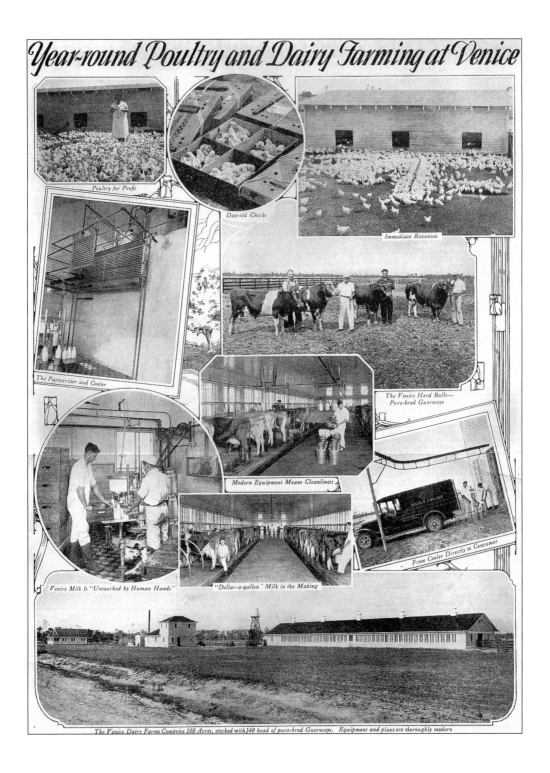

Poultry for Profit

Day-old Chicks

Immediate Revenues

The Pasteurizer and Cooler

The Venice Herd Bulls---Pure-bred Guernseys

Modern Equipment Means Cleanliness

Venice Milk Is "Untouched by Human Hands"

"Dollar-a-gallon" Milk in the Making

From Cooler Directly to Consumer

The Venice Dairy Farms Comprise 160 Acres, stocked with 140 head of pure-bred Guernseys. Equipment and plant are thoroughly modern

Seven

PROMOTIONS AND PLEASURES

The Brotherhood artificially stimulated the economy of Venice by spending about $500,000 a month on development and construction costs. So long as BLE Realty received loans and the Venice Company sold land, the bubble of prosperity was kept in mid-air. But just as the resort city moved into high gear, the palmy days of the Florida Land Boom came to a close. The job of finding and closing prospects, as well as getting loans, became more and more difficult as time went by.

During the Boom, Venice Company staffers executed many promotional projects, and they did it in an era that was devoid of televisions, computers, and the Internet. They published a local newspaper, designed brochures, wrote copy for ads and articles, engaged celebrities, and rounded-up sales prospects from all quarters of the country. The company's sales force spirited visitors around the "City By the Gulf" in company-owned cars, buses, and boats. They also arranged for beautiful roadside signs to be installed in a hundred places in Florida. Airplanes also figured into promotions. Aerial photographs of the unfolding city appeared in sales literature, air mail letters were dropped from aloft, and one day a stunt flyer actually landed near Hotel Venice and delivered fresh strawberries!

Sales promotions to the public began in February 1926, when about a half-dozen blocks in the Gulf View Section were placed on the market. According to Stanton Ennes, a Venice Company officer who later published a book about the Brotherhood's Florida venture, the effort met with only minimal success. In fact, sales volume that year amounted to $3,339,614. Results for 1927 were far worse—$1,729,829. To stimulate sales, Ennes noted that "every resource of high pressure selling was invoked. Extensive and intensive advertising was employed. Descriptive literature, books, pamphlets and pictures were made and widely distributed. Special writers and publicity men were secured, and moving pictures were made of Venice and shown in the Florida picture houses. Parties were organized to visit Venice, and generous entertainment was provided."

Brotherhood officials themselves also tried to arouse interest in their resort city. In January 1927, BLE Realty officer George Webb opened talks with Biltmore Hotel executive John

Bowman, hoping the latter would erect a resort facility in Venice. Webb also asked John Nolen to draw plans for the Rocky Point section of Venice (near today's airport). Here, Nolen conceived a beachside building with dancing and dining rooms as well as a "Sun Bake" on the upper level. Numerous bathing "nooks" were to be built replete with canvas awnings. Nolen also submitted plans for an "Artists Colony" on Lemon Bay that consisted of 18 acres of home sites plus another 10 acres for a casino. The latter was to have parking for 200 cars, a beachside restaurant, and a play pool for the kiddies. Two villages for citrus growers were also envisioned for the area. Alas, none of Webb's dreams materialized because the Boom fizzled and funds became scarce.

Of course one did not have to be a sales prospect to enjoy the pleasures of Venice. Residents and visitors could walk at will into the beautiful parks or revel in the glorious mainland beach. There was also boating, fishing, and restaurants, as well as dancing, golf, tennis, teahouses, and kaleidoscopic sunsets—themes that lent nicely to Venice Company ads, such as this one which appeared in numerous promotional brochures:

*T*he *Resort* *Supreme....*

A tropical Sea - A Wonderful beach. A city rich with the

architectural beauty of the Italian Renaissance.

—*A*—

Mystic Palms - Glorious nights - Boats slipping noiselessly by.

—*H*—

The wail of muted violins - The laughter of happy people - The crash

and rumble of the surf.

—*H*—

Truly a matchless setting for Venice, the new 'Resort Supreme' of

Florida's West Coast Riveira.

Aerial photographs recorded the construction progress in Venice, and the images appeared in articles and brochures. Here, photographer Asa Cassidy (in knickers) receives last minute instructions while the seaplane idles.

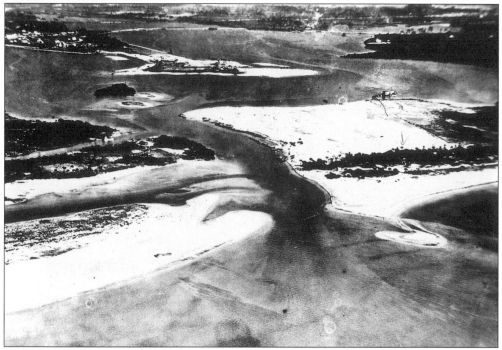

John Nolen planned a hotel, dancing patio, and jungle garden at Casey's Pass. They were never built, nor was a deep-water terminal on Venice Bay. However, the channel was deepened thanks to a hydraulic dredge, barely visible here on the backside of the Pass to the right.

A temporary gas dock was built by the Brotherhood at Casey's Pass. The vessel *Raven* (owned by the Venice Company) tied up here and shuttled prospective buyers around the resort city. Much of the fill was pumped up from the Gulf bottom by a hydraulic dredge in order to create new acreage.

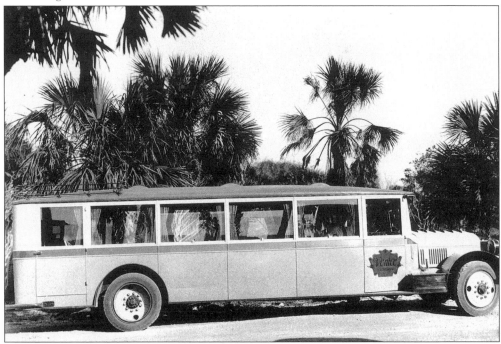

Every day Venice Company buses shuttled sales prospects through the "City By the Gulf." They were not air-conditioned, but window curtains supplied shade from the hot Florida sun. Luggage was strapped on top. Drummers accompanied the groups, reciting sales pitches and flashing contracts.

While creating Venice Farms, contractors unearthed the skeleton of a prehistoric mastodon. Work immediately halted and a Venice Company official sent a cable to the Smithsonian Institute in Washington, D.C., asking if the museum was interested. Quickly, word came back.

. . . Yes! A paleontologist was dispatched to Venice to confirm the find. Off went the bones, and the remains were re-constructed for all to see. Among the first to do so were President and Mrs. Calvin Coolidge. The specimen was likened to a fierce elephant.

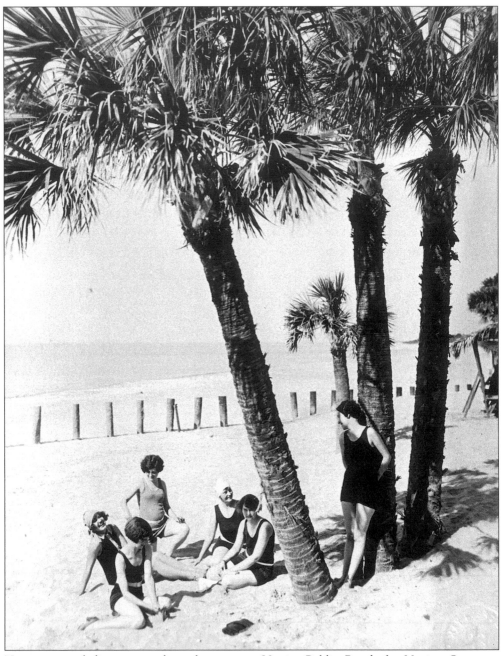

Happy young ladies pose under palm trees at Venice Public Beach for Venice Company photographer Jay Brown in 1926. Tea was served in a nearby thatched shelter, called "The Oasis."

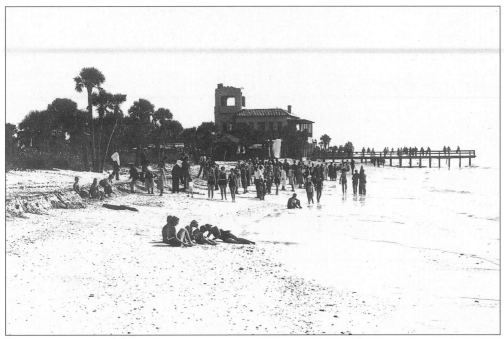

Dr. Fred Albee built the Venice Beach Pavilion that stood near the intersection of Ormond Street and the Esplanade. For a brief period, Venice Company offices were located in the upstairs part of the building. Almost all the bathers are facing the cameraman in this 1929 scene.

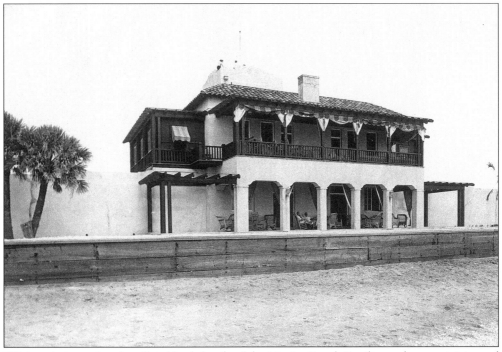

Wicker chairs and rockers lined both levels of the Venice Beach Pavilion, where activities and functions were once staged. The Sandbar Beach Resort occupies the spot today.

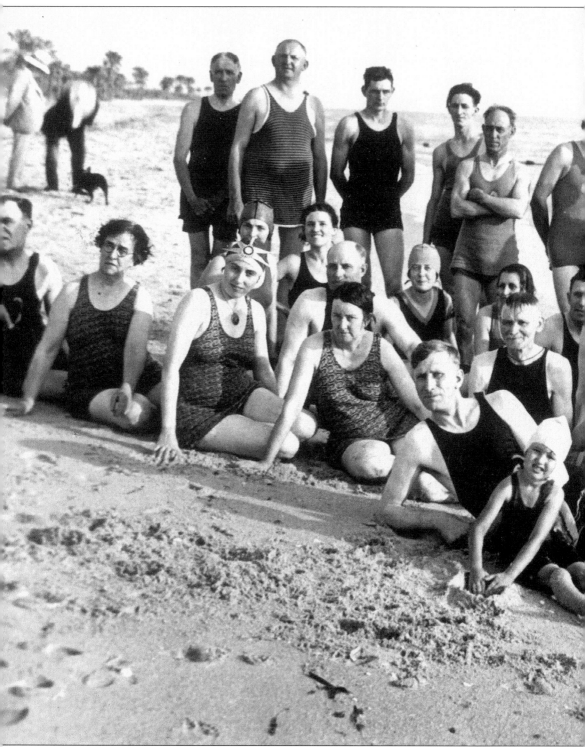

Members of the Venice Swimmers Club pose with friends at Venice Beach. The letter 'V' signifies regulars. Our "bathing cap award" goes to the third swimmer from left (front row).

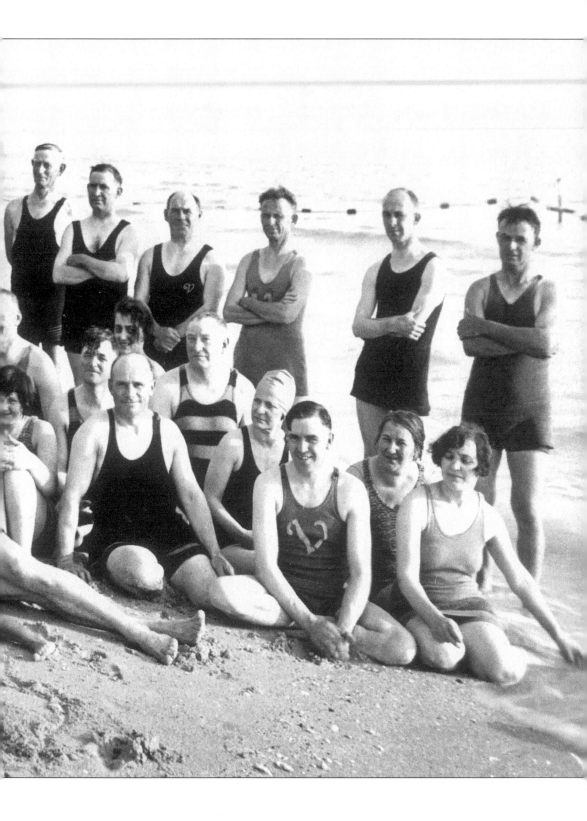

Sipping iced tea at the Oasis was a pleasant respite. Here, one could inhale the Gulf air, watch the waves and the crowds. Who cares if the ladies wore high-heels!

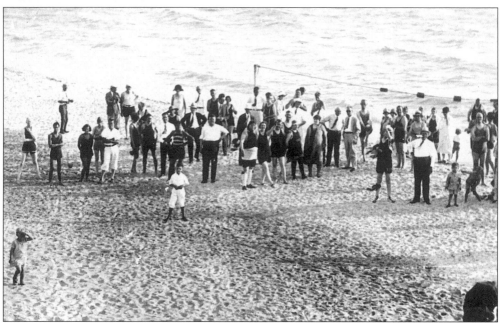

Leave it to Venice Company salesmen to bring prospects to the beach and have them photographed. Back home, the pictures kept interest in the new city brewing, and hopefully, some of the visitors who had their picture taken would come back and purchase.

104

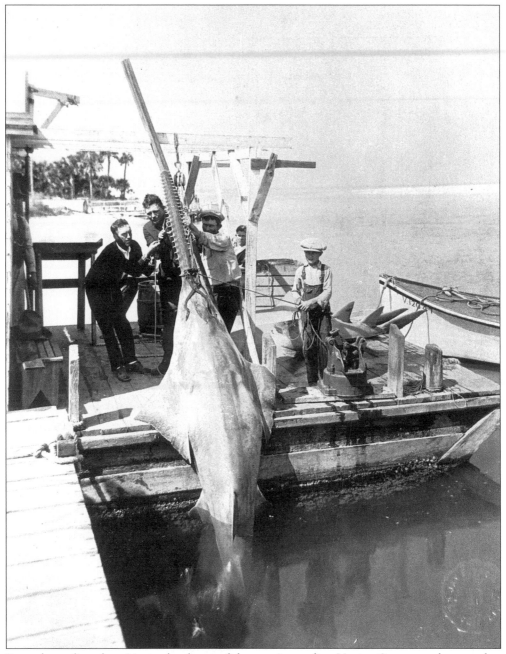

From the earliest days, Venice has been a fisherman's paradise. Venice Company photographer Jay Brown was at the ready when this giant sawfish was brought home in November 1926.

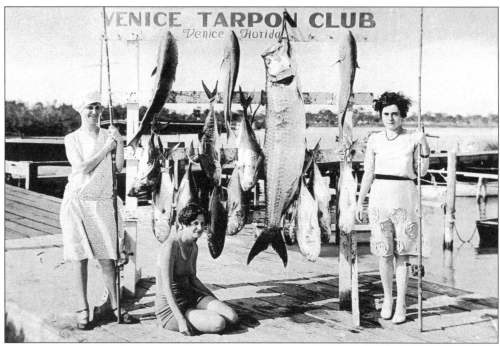

The Venice Tarpon Club organized a tournament in June 1926 with 200 fishermen. The following year, 7,500 participants appeared, including many women! Big cash prizes were awarded. The dock seen above was located near today's Venice Yacht Club.

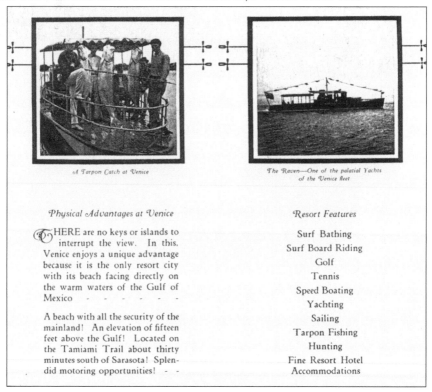

A Tarpon Catch at Venice

The Raven—One of the palatial Yachts of the Venice fleet

Physical Advantages at Venice

THERE are no keys or islands to interrupt the view. In this. Venice enjoys a unique advantage because it is the only resort city with its beach facing directly on the warm waters of the Gulf of Mexico - - - - -

A beach with all the security of the mainland! An elevation of fifteen feet above the Gulf! Located on the Tamiami Trail about thirty minutes south of Sarasota! Splendid motoring opportunities! - -

Resort Features

Surf Bathing

Surf Board Riding

Golf

Tennis

Speed Boating

Yachting

Sailing

Tarpon Fishing

Hunting

Fine Resort Hotel Accommodations

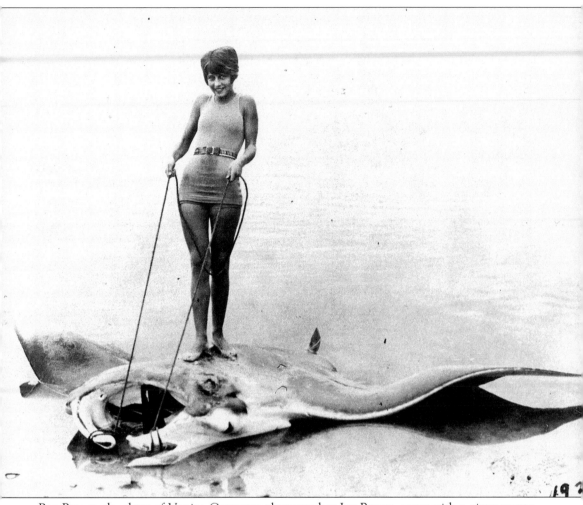

Bea Brown, daughter of Venice Company photographer Jay Brown, poses with a giant manta ray caught just a few hours before. Some 400 varieties of fish inhabited Gulf waters and the Myakka River. The greatest thrill of all? Tarpon, of course.

After a Day's Hunting near Venice

THE back country at Venice is "alive" with wild turkey. These elusive fowls afford excellent ort as it requires no mean skill to stalk them in their unts. Wild duck are found in abundance and when king another thrill Venice offers excellent hunting to guile lagging hours and appetites - - - - - - -

HE TANG of surf
the surf on swiftl
the line as the gia
these are the dominant not
Resort Supreme - -

With Venice's scintillatin
warm waters of the gul
facing directly on the o
Mexico, with its pines and
tropical suns, Venice brin
south seas—the glamour a

Against this background,
yachting, speed boat racin
golf, tennis and numerou
—a game to fit the hour—

ing—the thrill of riding
ving board—the tug on
arpon takes the hook—
the call of Sports of this

- - - - - -

lite beach swept by the
eam, a mainland beach
waters of the Gulf of
ns; its crashing surf and
you the mystery of the
ɔmance of Waikiki - -

fit your mood, there is
iling, hunting, dancing,
er sports and diversions
ort to fill the need - -

The Rendezvous of Discriminating Fisherman

OF ALL sports, Tarpon Fishing, provides t
greatest thrill. These kings of fish are fighte
to the last. They are the lion-hearted big game of t
sea. In the waters around Venice, the Tarpon abound
A challenge to your skill. your prowess, your sport
manship - - - - - - - - - - -

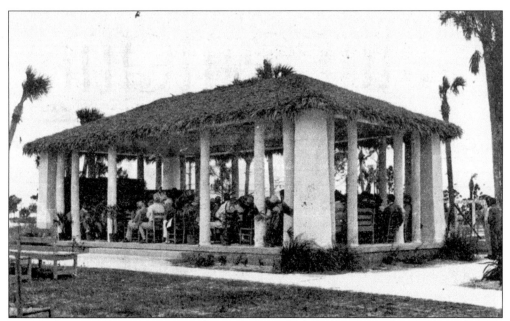

BLE Realty erected a community gathering lodge, which had a cement base and a palmetto-thatched roof, in the center of Venice. Various civic events were staged here, including open-air church services.

Billboards like the one shown above carried the Venice message to the motoring public. This one described industrial land sites. Other Venice Company signage extolled homes, hotels, or the pleasant ways of tropical life.

This Week in Venice was the local "rag" of the Venice Company. It contained the latest on new construction, events, as well as social news and gossip tidbits. The publication went far in arousing public interest.

The Venice News

FRIDAY, JUNE 3, 1927 PRICE 15 CENTS THE COPY

JULIUS DELBOS

Venice
Florida

The Venice News succeeded *This Week in Venice* sometimes, with pretty pastel covers, like this one by artist Julius Delbos. Articles covered every imaginable topic and event. Stories about Brotherhood projects or personalities naturally made headlines.

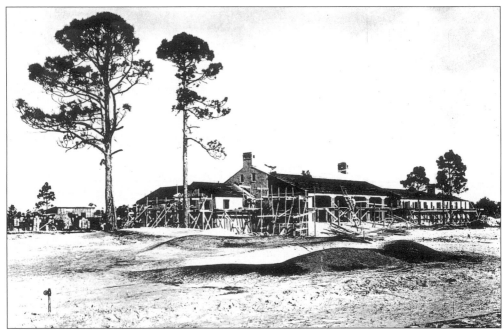

The BLE Realty clubhouse at the Venice Golf and Country Club nears completion in this image. The structure was designed by Brotherhood architects Walker & Gillette, and golfing architect Carl Anderson planned the course, reputedly one of the sportiest in Florida. The Venice Shopping Center and Country Club Estates now stand on the spot.

Carl Anderson (far left) and world-famous trick shot golfer Joe Kirkwood (second from right) appear in this BLE publicity photo. Not in knickers is Stanton Ennes, general manager of the Venice Company, who later wrote a book about the union's venture in Venice.

One Hundred Things to do at Venice

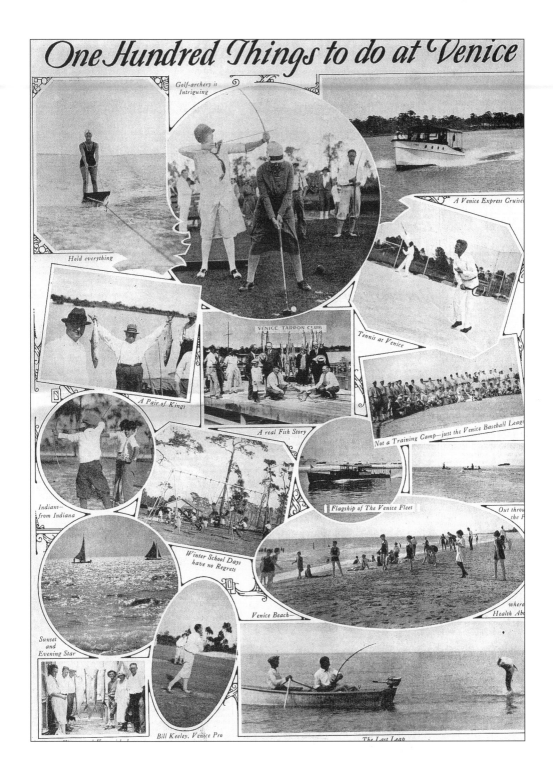

Golf-archery is Intriguing

A Venice Express Cruiser

Hold everything

Tennis at Venice

A Pair of Kings

A real Fish Story

VENICE TARPON CLUB

Not a Training Camp—just the Venice Baseball League

Indians— from Indiana

Flagship of The Venice Fleet

Out throu the

Winter School Days have no Regrets

Venice Beach—

where Health Abo

Sunset and Evening Star

Bill Keeley, Venice Pro

The Last Leap

One Hundred Things to Do at
~Venice~

No. 21 DANCING IN THE ORANGE GROVE—Dreamy music of the Lopez orchestra, soft cadences in the moonlight, overhead the leafy orange trees, and roundabout, romantic Florida in its very self. Dancing in the Venice Orange Grove, fanned by breezes from the Gulf—that is the crown of every active day—Good roads, hunting, sailing, game fishing, tennis, speed-boating, horseback riding, and home-grown fruits, vegetables and milk to reward the busy day. All roads lead this year to Venice. Sixty percent of rooms at $5, maximum $15—apartment house space available. Booklet on request.

THE VENICE COMPANY
100 Venice Blvd.
Venice, Florida

Venice Florida,
THE ONLY WEST COAST CITY ON A MAINLAND BEACH

Ad writers for the Venice Company were an imaginative lot. Their "One Hundred Things to Do" series described Venice activities, like "Dancing in the Orange Grove." Electrically lighted glass oranges were strung in orange trees; soft spotlights played on dancers. Our favorite ad? No. 37—"Loafing Actively."

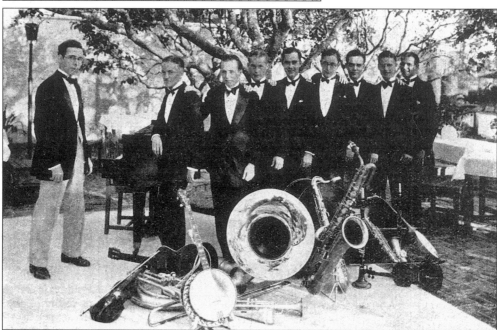

The "Orange Grove" (mentioned in the previous image) existed at Hotel Venice, and featured music by the Anthony Lopez Orchestra and his Venetian Serenaders. Lopez (far left) appeared at many Venice functions, including business events such as the opening of Venice Pharmacy.

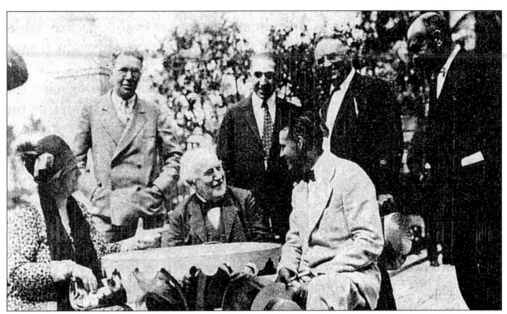

Venice Company officials rejoiced in celebrity visits. In March 1927, Mr. and Mrs. Thomas Alva Edison came up from their winter home in Fort Myers. Photos instantly made their way into newspapers, and press releases were put out over the national wire services.

CLASS OF SERVICE	SYMBOL
TELEGRAM	
DAY LETTER	BLUE
NIGHT MESSAGE	NITE
NIGHT LETTER	N L

If none of these three symbols appears after the check (number of words) this is a telegram. Otherwise its character is indicated by the symbol appearing after the check.

WESTERN UNION
TELEGRAM

NEWCOMB CARLTON, PRESIDENT GEORGE W. E. ATKINS, FIRST VICE-PRESIDENT

CLASS OF SERVICE	SYMBOL
TELEGRAM	
DAY LETTER	BLUE
NIGHT MESSAGE	NITE
NIGHT LETTER	N L

If none of these three symbols appears after the check (number of words) this is a telegram. Otherwise its character is indicated by the symbol appearing after the check.

The filing time as shown in the date line on full rate telegrams and day letters, and the time of receipt at destination as shown on all messages, is STANDARD TIME.

FULLERTON CALIFORNIA, DEC. 9, 1926

VENICE CHAMBER OF COMMERCE

VENICE FLORIDA

ENJOYED MIGHTY LAK A ROSE, LO, HEAR THE GENTLE LARK, TALKING TO THE MOON AND OTHER SONGS BY CONNIE CORSON STOP LOPEZ' ORANGE GROVE ORCHESTRA LOVELY STOP HEARD PROGRAM DISTINCTLY HERE SEVEN O'CLOCK STOP MANY THANKS TO VENICE CHAMBER OF COMMERCE AND VENICE NEWS STOP TRUST I AM ONE TO RECEIVE YEAR'S SUBSCRIPTION THIS STATE STOP

ELIZABETH BAILEY

EDITOR'S NOTE: This was the first of numbers of telegrams from all parts of the country which have been received since the broadcasting of "A Night In Venice" from Station WDAE on last Monday evening. A year's subscription to the Venice News was offered to the first person in each state to wire the Venice Chamber of Commerce.

The Venice Chamber of Commerce (Brotherhood-driven) arranged a nationwide radio broadcast in December 1926 featuring the Lopez Orchestra. Elizabeth Bailey cabled from California, named some of the tunes, and won a subscription to *The Venice News*.

Venice
FLORIDA

Bring the Wife and Kiddies to Venice for a real week-end

Venice is becoming the most popular week-end resort center on the west coast. Don't deprive yourself and family the many pleasures awaiting you at this cool, delightful spot.

Venice Beach is directly on the tumbling, turquoise waters of the Gulf, no keys to cross, no tiresome trips to and fro, and offers a matchless expanse of sand and surf for pleasure and privacy.

The Venice Bathing Pavilion, in its beautiful tropical setting, is strictly modern in every detail from its tinted tile roof to its concrete locker floors. Courteous attendants await your pleasure.

The cool Gulf breezes, the tangy air and a restful spot under a gay umbrella will make your wife forget her daily household routine—and the kiddies—just from the sheer comfort of it.

There's fishing too. The Venice Tarpon Club will gladly provide you with boats, tackle and a guide. Try your luck, because fisherman's luck in Venice waters is famous from coast to coast—the recent Tarpon Tournament proved that!

After a day's fishing or lolling on the beach you'll find your appetite keen as a razor. If you want a picnic lunch on the beach—the Pavilion Refectory has many tasty treats in store for you.

Venice is right on the Tamiami Trail and the Seaboard takes you to our "front door." If you own a yacht you can moor it in Venice Bay, entering through Casey's Pass. It's easy to get to Venice and pleasure awaits you here—hence make a note on your desk pad that you and the family are spending next week-end at Venice—you'll never regret it

(Please reserve your rooms at the Hotel in advance to avoid disappointment.)

Venice Highlights

1. Situated on Florida's mainland—directly on the open waters of the Gulf of Mexico

2. Nineteen miles south of Sarasota—half way between Tampa and Fort Myers—is the heart of the prosperous West Coast.

3. Four miles of Gulf front—and fourteen miles in depth.

4. On the Seaboard Airline Railway and the Tamiami Trail.

5. Venice is to be a port—a deep water harbor is being made in Venice Bay.

6. Venice is a city, planned by John Nolen and Associates Walter and Gillette, architects, and the George A. Fuller Company, contractors

7. Venice is destined to be a Resort and Commercial Center of the West Coast. It will thrive because it will be supported by industry and agriculture on its own 30,000 acres of property

8. Backed by enormous resources—assuring completion of this great undertaking.

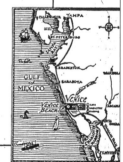

Florida's Best in Homes·Industry·Agriculture

Any of our offices will gladly give you further information or arrange a complimentary bus tour to Venice.

The Venice Company
Venice Florida,
103 MAIN STREET, SARASOTA

313 Twiggs Street, TAMPA; 120 Broadway, NEW YORK
528 Central Ave., ST PETERSBURG Hall Bldg., 19 Main St., OCALA 426 Main Street, BRADENTON
234 First Street, FORT MYERS 230 So. Kentucky Ave., LAKELAND 7 E. Washington St., ORLANDO
O'Malley, Cook & Durrance, Marion & King Sts., PUNTA GORDA Ft. Harrison Arcade, CLEARWATER
121 Magnolia Avenue, DAYTONA BEACH

EPILOGUE

The Brotherhood of Locomotive Engineers launched its big Florida venture in 1925. After acquiring some 30,000 acres of land, it engaged a renowned city planner as well as seasoned architects and a big construction firm. Soon, work began on the resort city's infrastructure—streets, water mains, storm sewers, sidewalks, etc. Lots went on the market in February 1926, and that summer, the first phase of the huge project was declared complete. Beautiful homes now appeared, hotels opened, and farm sites were advertised. New buildings began to dot the business section; inexpensive houses went up in Edgewood. The Seaboard Air Line Railway track was eventually relocated and a splendid station was built. Near it, an industrial park was established. Even though the palmy days of the Florida Land Boom were over, the Brotherhood forged "full steam ahead."

But there were chinks in the Brotherhood's armor. The cost of creating Venice (and other ventures) had caused considerable turmoil within the boardroom in Cleveland. By summer 1926, the terrific drain of funds had necessitated retrenchments elsewhere. The union's New York bank was sold in August not long after the sale of stock in the Empire Trust Company and the Equitable Building. In March 1927, the Brotherhood's attorneys warned President William Prenter that the union was in a dangerous financial condition. "There has been no estimate of the amount needed for expenditures in the Florida venture no provision that it is properly financed." Lawyers pressed for quick action, but radical changes did not occur until the Brotherhood held its triennial convention in Cleveland on June 6, 1927. Tensions ran high at the gathering, and soon the secret findings of the "Committee of Ten"—appointed to investigate the union's true financial affairs—were learned by the press. A Princeton University Press book on labor banking would later comment: "The huge losses, error of judgement, betrayals of confidence, nepotism, inefficiency, and extravagance that permeated the financial system, which had so long camouflaged itself as a great and glorious enterprise, were brought home suddenly to the bewildered delegates." Prenter, bedridden with pneumonia, could not appear on the convention floor to answer charges of "laxity, carelessness, and indifference." Regardless, he and senior officials were soon stripped of their offices.

Alvanley Johnston, an up-from-the-ranks railroader, now became the Brotherhood's Grand Chief Engineer. The so-called Committee of Ten (later "Eight") was ordered to take whatever action was necessary to correct the mess, including the employment of outside experts. Quickly they brought in Colonel Claudius H. Huston, the chairman of Transcontinental Oil and later head of the Republican National Committee. Then, an outstanding group of Cleveland businessmen replaced the union's investment board. A plan to liquidate bad investments evolved together with a compromised settlement with creditors. This resulted in a $5 million assessment against the Brotherhood. To raise the huge sum, real estate was mortgaged and "Loyalty Certificates" were sold to members.

Meanwhile, a long and painful decline began in Venice. The Venice Company begged for prospects, unsold homes were locked tight, and hotels were closed. In 1929, a book by Stanton Ennes appeared which chronicled more sordid facts about the union's Florida investment. That October, the stock market crashed. Florida's banks fell like dominoes, jobs vanished, and people left the state in droves. Local lawsuits started to pile-up against the union—litigation that would drag into the 1940s. Slowly the curtain came down on one of the most remarkable episodes in Boom history. Though Venice finally became a ghost town, the beautiful "City By the Gulf" refused to roll over and die.

Decades passed before Venice climbed out of its economic doldrums. An uptick occurred in 1932 when the Kentucky Military Institute moved its winter campus to Venice. Then, Dr. Fred Albee bought the Park View Hotel and opened his famed Florida Medical Center. During World War II, the U.S. Army established an air base at Venice, which also helped to improve the community's status. Gradually the city's charms began to attract transplants and retirees. New subdivisions appeared, and condominiums multiplied along the mainland beach. In 1978, the City of Venice unveiled a bas-relief of renowned planner John Nolen in Heritage Park. Previously, council members had adopted a resolution acknowledging Nolen's profound contributions, which helped to make Venice one of the most beautiful cities of its size in the nation. And as for the Brotherhood of Locomotive Engineers? After spending some $16 million in Venice, the union exited the world of high finance and made a full recovery. Today, it still is a potent labor voice in the transportation industry.

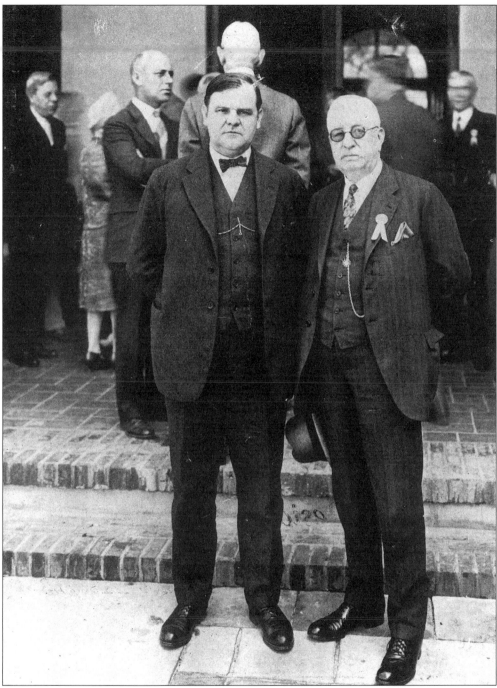

The Brotherhood of Locomotive Engineers held a regional gathering at Hotel Venice in 1927, and Governor John Martin (left) and Brotherhood president William Prenter greeted delegates. Martin addressed the crowd and said, "I see in Venice the dawn of a new era of prosperity, which will resound to the credit of the city, the state and the nation." But serious problems plagued the union, and later that year Prenter and co-executives were removed from office, their titles abolished.

March 18, 1927.

William B. Prenter, President,
The Brotherhood of Locomotive Engineers,
Cleveland, Ohio.

Dear Sir:

Since our conference held March 5, 1927, at which you, with Messrs. L. J. Griffing, A. Johnston, H. F. Daugherty, and C. E. Lindquist, members of the Executive Committee of the Brotherhood of Locomotive Engineers, together with Mr. George T. Webb and Mr. Oscar J. Horn, were present, we have received certain data from you which confirms us in the opinion that the Brotherhood of Locomotive Engineers, as a Brotherhood, is in an exceedingly dangerous position.

Mr. P. M. Arthur, during his lifetime, and his associates, built up the Brotherhood so that it occupied an enviable position in this country and its present membership of over ninety thousand (90,000) men, has a unique position and one that should be carefully guarded and protected.

A review of what has taken place within the membership since the death of Mr. Arthur impresses us that the Brotherhood has been undertaking to do and carry on business that members thereof were never trained to carry on and that through Mr. Warren S. Stone's leadership you have been fast running toward the rocks.

The building of the home for the Brotherhood in Cleveland we think could be regarded as a wise move. Every movement since that time, as has been shown to us, impresses us of very doubtful character.

The Brotherhood Bank was formed and through ambition or inexperience became loaded up with a lot of investments that evidently were not sound and would not pass the inspection of bank examiners. Then an Investment Company was organized and a large part of doubtful investments which the Bank had acquired were unloaded upon the Investment Company. The Investment Company had a capital of $10,000,000.oo of

In March 1927, Brotherhood attorneys issued a five-page missal, warning the union that its financial affairs were in an "exceedingly dangerous position." Nothing was done, but three months later at a national convention in Cleveland, secret findings were disclosed to a dazed membership. Then, the fireworks began.

In one of their last photographs in Venice, President William Prenter (right) poses with BLE Realty executive George T. Webb (left). In the end, the union spent some $16 million on the resort city. When funds dried up, the union closed down and left. Today, 120 structures that were built in the Brotherhood days still stand.

The December 1929 issue of *Nation's Business* magazine ran a feature article about the Venice disaster. Writer Van Fleet claimed that the biggest culprit was bad management. The union had also paid top-of-the-market prices for land and launched the huge project just as the Florida Land Boom had peaked.

This hotel, built by the Brotherhood at its Venice, Florida, development shows the smart style in which things have been carried forward there

A Disaster in Management

By FREDERICK A. VAN FLEET

⚫ GOOD management is vastly more essential to business success than is money, the Brotherhood of Locomotive Engineers has learned. This lesson in the importance of management has been costly, but the Brotherhood is standing up to its responsibilities in sturdy fashion

PART TWO

IN ALL the story of the financial adventures of the Brotherhood of Locomotive Engineers there is no more amazing chapter than that relating to the venture in Florida lands—amazing because of its scope, amazing because of the way money was poured into it, doubly amazing because, undertaken as a quick turn to recoup losses, it dragged out into the greatest financial disaster the Brotherhood had known with losses that made previous deficits look small.

The financial history of the Brotherhood divides itself naturally into what happened before the death of Warren S. Stone and after. While that is true it is also true that the second chapter was written as a sequel to the first—that the officials left in charge of the Brotherhood only did what Stone was contemplating and would probably have done himself if he had lived.

There is one difference in the two chapters of the story. The enterprises in which Brotherhood money was invested and to which Brotherhood money was loaned before Stone's death were varied in character. With a little better luck a larger percentage of them might have

succeeded even with indifferent management and the gains come nearer balancing the losses. But the Florida enterprise was all one gigantic scheme, comprehensive in character and so definite in detail that without wisdom, experience and ability at the helm its ship was doomed to founder before it ever left the dock.

We have seen how the Brotherhood advisory board, when it learned from Stone of the losses already incurred began looking around for some way to recoup quickly, and that Stone himself had been considering an investment in Florida lands, where much quick money had been made.

They bought at the top

AFTER the death of their leader advisory board members announced that further expansion was contemplated. Within 60 days, however, announcement came that the Brotherhood had purchased 27,000 acres of land (after

The Locomotive Engineers Investment

in

Florida Real Estate

Venice

By
STANTON ENNES
1929

Stanton Ennes was a former officer of both BLE Realty and the Venice Company. In 1929, he authored a book about the union's investment in Venice that was not entirely complimentary. He harbored distaste for his one-time boss, George T. Webb.

Grand Chief Engineer Alvanley Johnston came to Brotherhood power in 1927 and brought order out of chaos. Financial solvency was eventually restored, and Johnston's popularity proved so great that he remained in office until 1950. (Courtesy of Brotherhood of Locomotive Engineers.)

CERTIFICATE No. **$100.00**

BROTHERHOOD OF LOCOMOTIVE ENGINEERS

Loyalty Certificate

This is to Certify that,_____

has paid the sum of One Hundred Dollars ($100) to the Loyalty Fund of the Brotherhood of Locomotive Engineers, which sum shall bear interest at the rate of four per cent (4%) per annum from the date hereof.

The face value of this certificate and the accrued interest thereon shall be paid to the above named, or his heirs, when, as, and if the Advisory Board and the Trustees of the Financial and Investment Department of the Brotherhood, in their discretion, are able to pay this certificate, or any part thereof, out of available funds derived from the earnings or the liquidation of the assets administered by the said Trustees, but shall not be a lien upon or paid from any other property or funds of said Brotherhood. This certificate is not assignable.

This certificate is one of a series of one hundred thousand (100,000) certificates in denominations of One Hundred Dollars ($100) each authorized by the Fifth Triennial Convention of the Grand International Division of said Brotherhood, and constitutes the entire contract of said Brotherhood with the holder hereof for the repayment of the purchase price of this certificate.

In Witness Whereof, the Grand International Brotherhood of Locomotive Engineers has caused this certificate to be signed by its duly authorized officers and its seal

[SEAL]

attached hereto at Cleveland, Ohio, this.........day

of.................

Grand International Brotherhood of Locomotive Engineers

A. Johnston
Grand Chief Engineer

Jas H Cassell
General Secretary-Treasurer

The "Committee of Ten" hired experts to clear up the union's financial problems. They, in turn, levied a $5 million assessment upon the Brotherhood itself. To pay the bill, real estate was mortgaged and "Loyalty Certificates" were sold to the membership. Luckily, the formula met with success. (Courtesy of Brotherhood of Locomotive Engineers.)

John Nolen generated plans for several Venice projects that were never built. The sketch here, rendered in March 1927, depicted a building group that housed all municipal functions—city hall, library, community building, auditorium, plus fire and police stations. Patios and arcades enhanced the setting. (Courtesy of Division of Rare and Manuscript Collections, Cornell University Library.)

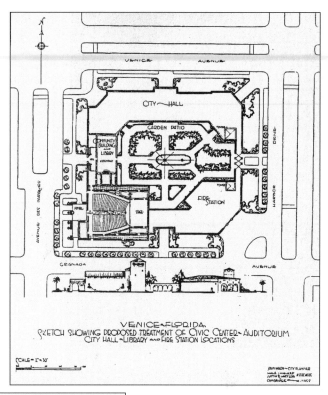

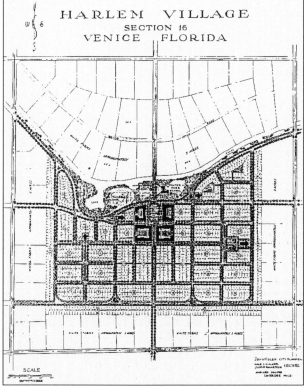

Readers will remember that Nolen's big regional plan for Venice included a village for African-American workers. Buildings and stores would have comprised the subdivision as well as parks, churches, schools, and a swimming lake. Gulfstream Land and Development now occupies the site. (Courtesy of Division of Rare and Manuscript Collections, Cornell University Library.)

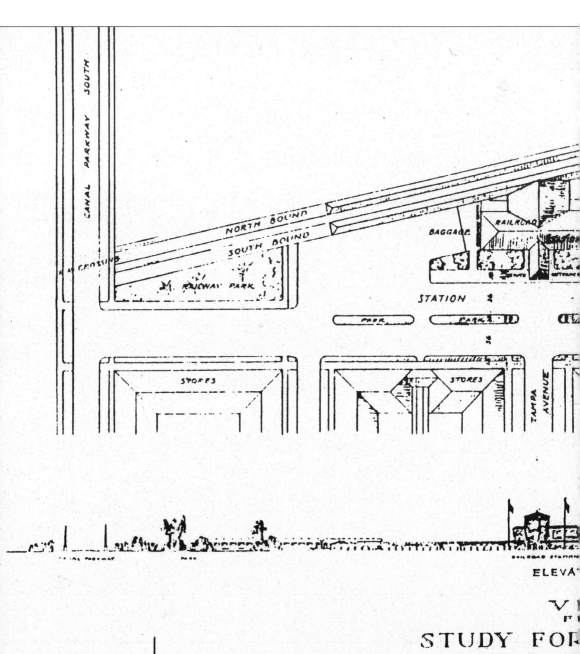

The Venice railroad station, which stands today, was opened in 1927. Prior to its construction, Nolen envisioned a huge station plaza for the area that would include stores, a marketplace, and

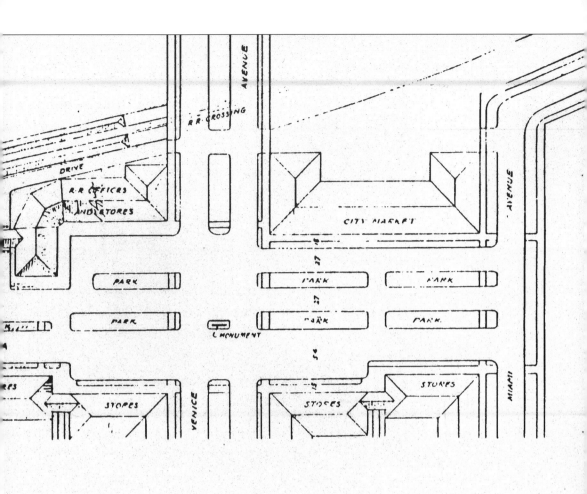

parking spots—in essence a commercial trading point. It was never built. (Courtesy of Division of Rare and Manuscript Collections, Cornell University Library.)

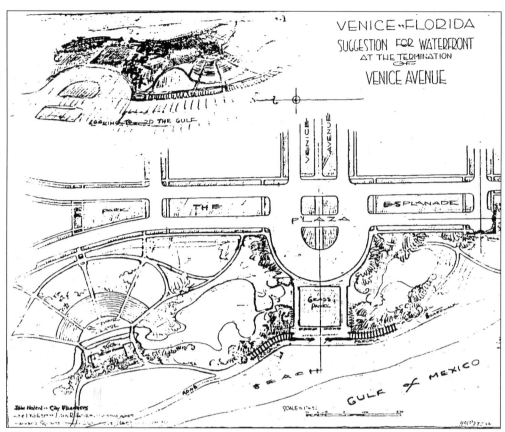

The *piece de resistance* of Venice was of course its superb mainland beach, and John Nolen had specific ideas as to how Venice Avenue should terminate at the Gulf. He envisioned a plaza with a large grass panel. A music theater was planned due north, and a boardwalk would snake its way along the beachfront. Had the Boom not petered out, perhaps it would have all been built. (Courtesy of Division of Rare and Manuscript Collections, Cornell University Library.)

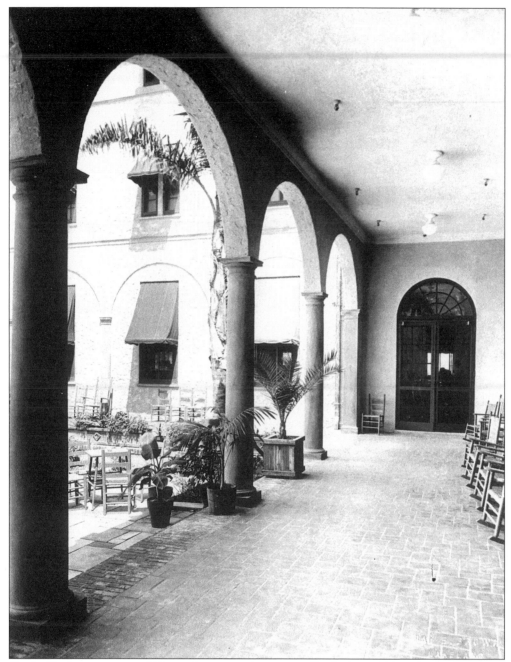

Gradually the resort city of Venice became a ghost town. By the late 1920s, sales prospects had vanished, businesses closed, and guests no longer came and went at Brotherhood hotels. In this poignant image, empty rockers line the porch and patio of Hotel Venice. Lopez and his Venetian Serenaders had departed by now, and there were no more dances in the lovely Orange Grove. However, once the Kentucky Military Institute arrived in 1932 and occupied the building during winter months, life began anew.

Further Reading

Albee, Fred H. *A Surgeon's Fight to Rebuild Men.* New York: E.P. Dutton & Co., 1943.

Albee, Louella B. *Doctor and I.* Detroit: S.J. Bloch, 1951.

Board, Prudy Taylor and Esther B. Colcord. *Venice Through the Years.* Venice Beach: The Donning Company, 1995.

Districts and Structures on the National Register: Venice, Nokomis, Laurel and Osprey. Venice: Venice Archives and Area Historical Collection, 1999.

Ennes, Stanton. *The Locomotive Engineers Investment in Florida Real Estate.* Venice: Sarasota Times, 1929.

Glass, James Arthur. *John Nolen and the Planning of New Towns: Three Case Studies.* Master's thesis, Cornell University, August 1984.

An Historical and Architectural Study. Venice: The City of Venice, Florida, 1985.

History of the Brotherhood of Locomotive Engineers. Cleveland: Brotherhood of Locomotive Engineers, 1998.

Matthews, Janet Snyder. *Venice: Journey From Horse and Chaise.* Sarasota: Pine Level Press, 1989.

Nolan, David. *Fifty Feet in Paradise: The Booming of Florida.* New York: Harcourt, Brace & Jovanovich, 1984.

The Labor Banking Movement in the United States. Princeton: Industrial Relations Section, Princeton University, 1960.

Ross, Ishbel. *Silhouette in Diamonds: The Life of Mrs. Potter Palmer.* New York: Harper Brothers, 1960.

Turner, Gregg M. *Railroads of Southwest Florida.* Charleston, SC: Arcadia Publishing, 1999.

Youngberg, George E. and W. Earl Aumann. *Venice and the Venice Area.* Venice: Feather Fables Publishing, 1995.